THE GALLERY
OF WEST BOHEMIA
IN PILSEN

50 MASTERPIECES OF CZECH CUBISM

FROM THE COLLECTIONS OF THE GALLERY OF WEST BOHEMIA IN PILSEN

SCALA

THE COLLECTION OF CZECH CUBISM IN THE GALLERY OF WEST BOHEMIA IN PILSEN

Západočeská galerie v Plzni (The Gallery of West Bohemia in Pilsen) manages one of the most comprehensive and highest quality collections of Czech cubism, comprising works from the period of 1910 to 1925, as well as those produced as late as the early 1940s. Oldřich Kuba, the first director of the Regional Gallery in Pilsen (the predecessor of the present Gallery of West Bohemia), started to build the collection in the early 1960s. The crucial impulse and undoubted inspiration for him were two exhibitions: *Zakladatelé českého moderního umění* (*The Founding Fathers of Czech Modern Art*), displayed at the Brno House of Arts in 1957, and the monographic exhibition of Bohumil Kubišta at the Mánes Gallery in Prague in 1960. The former, which also presented the art of Czech cubism in a representative selection, contributed to the rehabilitation of the avant-garde, which had been severely suppressed during the Nazi and Communist totalitarian regimes – it was not allowed to be exhibited and its artists were persecuted. The latter exhibition highlighted the importance of the leading personality of its generation, whose legacy was embraced by representatives of Czech modernism during the interwar period, as well as by artists entering the art scene in the 1950s and 1960s. Both exhibitions therefore became landmarks in terms of restoring the continuity of the development of the Czech art scene; they had an inspiring influence on contemporary Czech artists and also sparked new interest in the founding figures of Czech modern art. All this was reflected in the acquisition strategies of some state-managed and newly built regional galleries in the Czech Republic, among which the Gallery of West Bohemia, founded in 1953, was the most prominent.

Oldřich Kuba, who closely monitored the preparation and implementation of both exhibition projects, soon developed a strong affinity for the work of Bohumil Kubišta, by whom he was literally enchanted. His infatuation went so far that he even approached the organisers of Kubišta's exhibition, the exhibiting headquarters of the Union of Czechoslovak Visual Artists, and asked them to provide the

View of the exhibition
Cubism in the Collections of the Gallery of West Bohemia in Pilsen (1910–1925),
GWB 2009

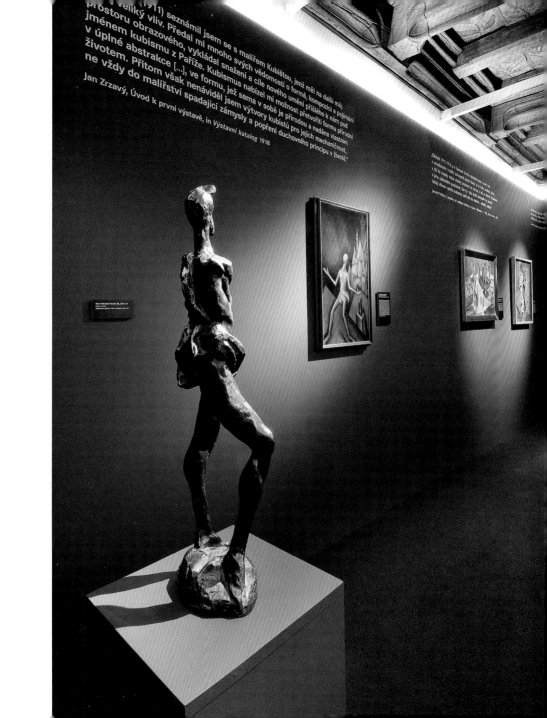

...veliký vliv. Seznámil jsem se s malířem Kubištou, jenž měl na další můj prostoru obrazového, vykládal snažení a cíle nového umění přišlého k nám pod jménem kubismu z Paříže. Kubismus nabízel mi možnost přetvořiti formu přírodní v úplné abstrakce [...], ve formu, jež sama v sobě je přírodou a nadána vlastním životem. Přitom však nenáviděl jsem výtvory kubistů pro jejich mechaničnost, ne vždy do malířství spadající zámysly a popření duchovního principu v životě."

Jan Zrzavý, Úvod k první výstavě, in *Výstavní katalog* 1918

addresses of all private lenders of Kubišta's works for the aforementioned exhibition. From 1960 onwards, he would send letters to the owners persistently asking them to sell until he succeeded in obtaining the desired artworks. This plan, code-named 'Operation Kubišta' by Director Kuba, paid off enormously as it enriched the Gallery with a number of important works by the artist in the following years. As a result, the Gallery today manages one of the best collections of works by Bohumil Kubišta in the Czech Republic, forming an important pillar of its entire cubist collection. One of Kubišta's programme works, *The Judgement of Paris* (1911), was also the first cubist painting that Director Kuba purchased for the Gallery's collection in 1960. Three years earlier, the Gallery had acquired a cubist painting *Woman with a Bird* (1934) by Emil Filla, another key artist of the Czech cubist generation, but it had been acquired rather by chance, as it was transferred together with 20 other paintings by various artists from the National Gallery in Prague to the Regional National Committee in Pilsen, the establishing authority of the Gallery of West Bohemia. Over time, Director Kuba gathered a very representative and large collection of Filla's works that encompasses all the artist's important creative periods.

From the early 1960s the Gallery also received works by other representatives of Czech modernism, including Otto Gutfreund, Antonín Procházka, Josef Čapek, Václav Špála and Jan Zrzavý, who more or less responded to the impulses of cubism. Purchases of works by all these artists for the Gallery of West Bohemia in Pilsen were rather frequent throughout the 1960s and 1970s. The following decade, namely from 1980 onwards, saw a significant decline in these acquisitions, however, which can be explained both by the gradual increase in prices and, above all, by the fact that the works of these artists were no longer available to such an extent in private collections or in the families of the artists from whom Director Kuba used to buy most frequently. This was particularly true of acquisitions of works by Josef Čapek, Václav Špála, Otto Gutfreund and Emil Filla.

Some years were truly extraordinary in terms of purchases of the works by the above-mentioned artists. In 1973, for example, Director Kuba bought 11 of their works for the Gallery (five paintings by Václav Špála, three paintings by Emil Filla, two paintings by Josef Čapek and one painting by Bohumil Kubišta); in 1965 it was 10 works (five paintings by Emil Filla, three paintings by Bohumil Kubišta, one painting by Antonín Procházka

and one painting by Václav Špála); and in 1971 it was also 10 works (three paintings by Václav Špála, three paintings by Josef Čapek, two paintings by Emil Filla and two paintings by Bohumil Kubišta). Over the aforementioned 20 years, the purchasing committee of the Gallery of West Bohemia bought an average of five to six works from this artistic generation a year; among them were works of fundamental significance that rank among the treasures of Czech art history. In 1961, for example, Bohumil Kubišta's painting *The Resurrection of Lazarus* (1911–12) was purchased for CZK 16,000; in 1965, Václav Špála's *Three Women by the Water* (1919) for CZK 15,000; in 1975, Otto Gutfreund's bronze sculpture *Concert* (1912–13) for CZK 78,000; and in 1979, Emil Filla's still life *Bottle, Glass and Pipe* (1913) for CZK 49,000. From the present point of view, when the works of these artists are available on the art market for tens of millions of dollars, this is a fascinating balance that probably no budgetary institution, be it a state-operated or a regional gallery, will be able to reproduce.

In the context of the acquisition strategy of the Gallery of West Bohemia in Pilsen, it is interesting to see the attention that was paid to these artists in terms of the exhibition programmes. Director Kuba initiated the implementation of exhibitions displaying works of Václav Špála (1965, 1968), Bohumil Kubišta (1967), Jan Zrzavý (1967) and Josef Čapek (1968, 1975). In 1966, a long-term exhibition *České umění 20. století* (*Czech Art in the Twentieth Century*) was also displayed on the premises of the Museum of West Bohemia in Pilsen, where the Gallery was temporarily housed from the beginning of its existence until 1985. Representatives of Czech modernism were also included there. It is on the face of it only surprising that during the 1960s and 1970s, when intensive purchases of all these artists' works were being made, the Gallery did not display any exhibition dedicated to Emil Filla, who had a major influence on the cubist movement in Bohemia from its beginnings.

After 1948, when the cultural policy of the Communist regime consistently implemented the doctrine of socialist realism, Emil Filla was perceived as one of the main exponents of Western bourgeois art. An irreconcilably negative attitude towards Filla was adopted also by the representatives of the Communist-controlled Union of Czechoslovak Visual Artists. They held a 'debate' with him on 21 June 1951 at the Mánes Gallery in Prague, at which Filla's work was subjected to a com-

View of the exhibition *KUBIŠTA – FILLA.*
Pilsen Disputation, GWB 2019

1911–1918

Konstelace IV
Rozchod

Constellation IV
Breakup

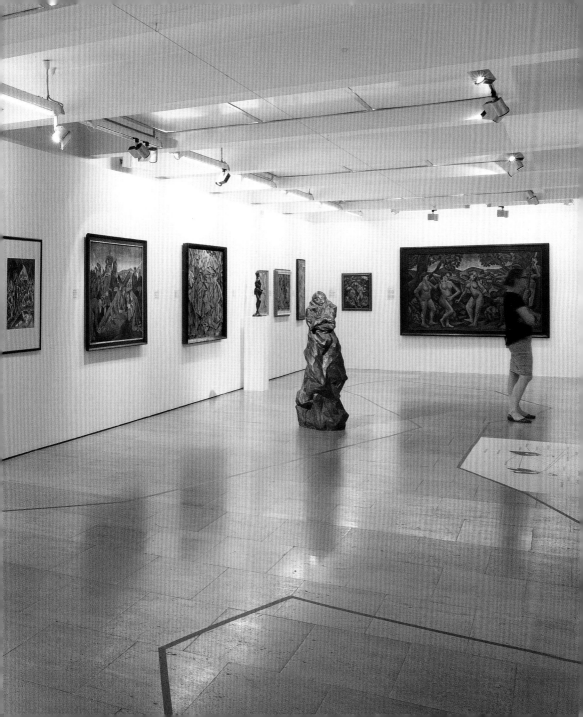

pletely overwhelming criticism that eventually led to the banning of his forthcoming exhibition – a series of large-scale ink drawings on the motifs of Slovakian and Moravo-Slovakian folk songs. This 'trial' against Filla ultimately led to the fact that, over the following four decades, of his entire work only an 'ideologically benign' series *České středohoří* (*Central Bohemian Highlands*) from his late period of work activity, or perhaps some individual sheets from the graphic cycle *Boje a zápasy* (*Fights and Struggles*), which were created at a time of anxiety from the emerging Nazism, were exhibited. A completely different approach was adopted to the work of Bohumil Kubišta, who died in 1918 and therefore could not be identified with the cultural scene of the Masarykian First Czechoslovak Republic (1918–38), which was a thorn in the side of the Communist rulers. Filla's full artistic rehabilitation did not take place until 1987, when a major retrospective exhibition was held at the Prague City Gallery, accompanied by an expert colloquium at which his work was comprehensively evaluated for the first time since his death in 1953. A similar fate, however, befell some of his other colleagues, such as Josef Čapek and Otto Gutfreund, whose cubist works were also banned from exhibition halls during the period of so-called 'normalisation' in the 1970s and 1980s.

For these and other reasons, it took 20 years after the Velvet Revolution before the collection of Czech cubism from the collections of the Gallery of West Bohemia was presented in 2009, including its art-historical evaluation. In 2017, the Gallery presented an exhibition dedicated to the most important personality of Czech cubist sculpture, Otto Gutfreund, the core of which was, once again, the works from the collection of the Gallery of West Bohemia. Finally, in 2019, the Gallery organised an equally important exhibition dedicated to the founding figures of Czech cubism, represented by their works from its collection, presented under the title *Kubišta – Filla. Plzeňská disputace. Zakladatelé moderního českého umění v poli kulturní produkce* (*Kubišta – Filla. The Pilsen Disputation. Founders of Modern Czech Art in the Field of Cultural Production*), which, among other things, presented the complex personal and work relationships of both protagonists.

Roman Musil

CZECH CUBISM

Along with Czech surrealism, Czech cubism is now considered the most important contribution of modern Czech art to world culture. The works that are referred to as cubist, in the Czech context, were created between 1910 and 1935 and include not only paintings, drawings, prints and collages but also sculptures and architectural realisations. Art historians consider the most important representatives of these works to be Emil Filla, Bohumil Kubišta, Josef Čapek, Vincenc Beneš and Antonín Procházka in painting; Otto Gutfreund in sculpture; and Josef Gočár, Pavel Janák, Josef Chochol and Vlastislav Hofman in architecture. The fact that the cubist principles and forms established themselves in the Czech variant of cubism, be it sculpture, architecture or applied arts, so early after they had been first formulated, is often considered a peculiarity of the 'Czech cubism'.

However, these specifics cannot be examined without reference to Parisian cubism, which developed from 1907 onwards in the work of Pablo Picasso and Georges Braque. It is the work of these two painters that is still considered by art historians to be fundamental for the reassessment of the pictorial rendering associated with the term cubism. At the time, it was used to describe the work of completely different artists, the so-called 'Salon cubists', such as Albert Gleizes, Jean Metzinger, Henri Le Fauconnier, Robert Delaunay, Fernand Léger, etc. The rivalry that existed in Paris before the First World War between Picasso and Braque on the one hand and the Salon cubists on the other also influenced the institutional functioning of Czech cubism. Above all, it was reflected in the agenda of the Prague *Skupina výtvarných umělců* (Group of Fine Artists, 1911–14) and its *Umělecký měsíčník* (*Art Monthly*) magazine, steered by Emil Filla towards unreserved admiration of Picasso and rejection of Salon cubism and other contemporary movements. Filla found theoretical support for his 'Picassism' in one of the first collectors of cubism, the art historian Vincenc Kramář, who bought most of the works for his collection from Picasso's Parisian gallerist Daniel-Henry Kahnweiler.

The term 'cubism' is derived from the French word *le cube* (the cube). The word *le cubisme* was allegedly first used in 1908 by the French critic

Emil Filla, 1920s,
Archives of the National Gallery in Prague

Louis Vauxelles to label the paintings of Georges Braque. However, the understanding of cubism as 'painting cubes' only holds water in connection with Braque's and Picasso's work from the brief period of 1908–09 (Braque's landscapes from L'Estaque and La Roche-Guyon and Picasso's from Horta de Ebro). The paintings from this period, as well as Picasso's works from the so-called proto-cubist period (1907–08), did not yet apply the pictorial principles characteristic of the cubist revision of Western pictorial representation. These are not found earlier than in the period of the so-called 'Analytical cubism', which Picasso and Braque developed together in 1909–12. Analytical cubism abandoned illusory perspectivism and replaced it with a conceptual representation of the object, whose gradual decomposition on the surface of the canvas is meant to stimulate the viewer's recollection of its various spatial qualities. A vivid image of the object, depicted as if from many angles at once, becomes present in the mind. Early advocates and interpreters saw in cubism an epistemological revolution, penetrating through the external form of reality to a truer form of things – to the Kantian *Ding an sich* (thing-in-itself).

In the analytical phase of cubism, the image-object (*tableau-objet*) is thus broken down into its individual parts and analysed artistically, and in the following phase it is reassembled, namely synthesised. Collages were characteristic of synthetic cubism, appearing in the work of Picasso and Braque from 1912 onwards. The newly created exempt sign becomes the main medium of representation. At the same time, the cut-outs applied in collages are an even bolder challenge to the illusionistic painting of the past, as they acknowledge the flatness, artificiality and arbitrariness of the representation of objects and space in synthetic cubist works. The heroic phase of cubism lasted until the outbreak of the First World War in 1914. In the 1920s and 1930s, cubism began to embrace organic, rounded forms. While so-called 'curvilinear cubism' responded to the current impulses of surrealism, it no longer represented the most current trend of the interwar avant-garde.

European critics and art theorists began to realise that Czech modern art had a very close relationship with cubism as early as 1911–14. In 1936, Vincenc Kramář labelled Emil Filla as an important representative of cubism, developing the most striking artistic qualities of this movement in parallel with Picasso. Thanks to his travels to Paris and his

visits to Kramář's collection, Filla became acquainted with Picasso's and Braque's works and gradually tried to become more familiar with the precepts behind them. His works from 1910–12, however, inspired more by proto-cubism rather than cubism proper, still followed the tradition of Central European symbolism. The narrative line, often psychological, existential themes and expressive urgency were still important to them. The early works of Bohumil Kubišta from this period – who, like Filla, was a former member of the Prague expressionist group Osma (The Eight, 1907–08) – were similarly attuned. The Czech art historian Miroslav Lamač described this trend – more cubist-like rather than cubist – as 'cubo-expressionism'. However, in 1911, Filla himself, probably in close collaboration with Bohumil Kubišta, referred to this joint programme of the young generation as 'neo-primitivism'.

In the following years, the paths of the two representatives of the same generation diverged. Filla applied Picasso's method more consistently and followed his example through the analytical and synthetic phases of cubism. During the First World War, while in exile in Amsterdam and Rotterdam, he enhanced 'his' cubism with impulses drawn from the verisimilitude found in the works of the old Dutch masters. Bohumil Kubišta did not identify with Filla's views on cubism and did not join the Group of Fine Artists' activities. In his work Kubišta sought an adequate expression of modern spirituality and executed both symbolically and existentially toned paintings in a cubist-like spirit. He solved the problems of representation of a three-dimensional object, spatial depth and temporal simultaneity through cubism, which rather contrasted with Picasso and created a fully fledged alternative to his system. Of the cubists working in Paris, Kubišta was closest to Juan Gris, but this was more a matter of artistic affinity than direct influence. At the same time, Kubišta's consistent interest in old art led him to the implementation of large-scale compositions in which the inspiration of proto-cubism and cubism was balanced with the lessons he learnt from El Greco, Nicolas Poussin and Peter Paul Rubens. In 1918, Kubišta died, aged 34, during the Spanish flu epidemic.

Josef Čapek was a founding member of the Group of Fine Artists, but he soon labelled Filla's attitude as Picassian dogmatism, and left it, together with several friends, in 1912. His cubist works reveal an openness to a range of influences, from modernist movements outside of cubism

Bohumil Kubišta, 1911,
Archives of the National Gallery in Prague

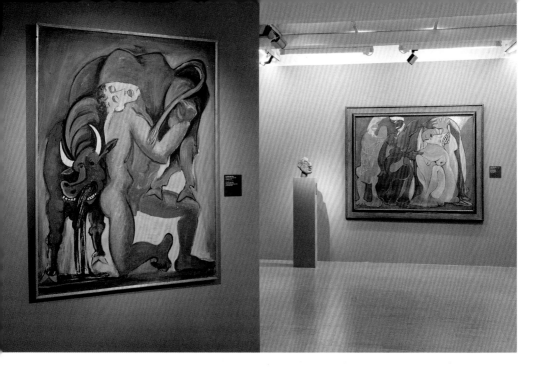

to African art, folk art and unschooled art. The result was paintings possessing an original character and elementarism of form. Unlike the members of Filla's Group, Čapek did not explicitly reject the impulses of Italian futurism. In fact, Bohumil Kubišta also reacted to it in several of his works in a very original way.

A similarly free treatment of cubist morphology can be found in the work of Václav Špála, which in this period also stemmed from the roots of sensualism and colourism. A sensual understanding of colour was also characteristic of the cubism of Antonín Procházka, otherwise a faithful member of the Group. Under the guidance of his friend and mentor Bohumil Kubišta, Jan Zrzavý approached cubism in several paintings. However, he was one of the artists who never tried to apply the cubist system consistently. Nor did Georges Kars, a Czech-born, German-speaking artist of Jewish origin who had long resided and worked in France.

The Czech sculptor Otto Gutfreund is an extraordinary phenomenon in the context of European cubism. Picasso dealt with the problem of sculpture only sporadically during his cubist period, and sculptors such as Raymond Duchamp-Villon, Jacques Lipchitz, Henri Laurens and Ossip Zadkine realised their cubist works with a delay of several years compared to Gutfreund, whose cubism peaked in 1912–13. Emil Filla also contributed several solitary works to the phenomenon of cubist sculpture.

Czech interwar architectural and design work is traditionally also associated with cubism, which after the First World War developed into a decorative aestheticised form of so-called 'rondo-cubism', also called the (Czech) 'national style'. It combined cubic shapes with rounded architectural elements, inspired also in colour by Czech folk art. In the 1920s, rounded, organic lines also began to penetrate the cubist compositions of Emil Filla or Alfred Justitz. Their works from this period are often called 'lyrical cubism' or 'imaginative cubism'. In the work of other artists, such as Antonín Procházka, cubism in the interwar period was intertwined with the contemporary interest in the everyday, idyllic bourgeois life. At the same time, after the First World War, cubist forms became an essential part of the register of modernist morphology and experimentation with them was part of an artist's obligatory training. Traces of cubism can still be found in the work of some artists in the 1930s, but they are often intertwined with the surrealist imagery of ghostly scenes and deformed figures.

Cubism was associated by artists in Bohemia with an ambitious project of a universal new art that would penetrate all spheres of modern man's everyday life. Despite the sophistication of the cubist aesthetic, which in Bohemia targeted virtually all artistic genres, this vision of a great modern style remained an unfulfilled utopia. A similar fate befell cubist art forms in France when they attempted to penetrate the field of applied art and design in the 1920s. At the *Exposition internationale des arts décoratifs et industriels modernes* in Paris in 1925, the expected total occupation of the terrain of everyday life by cubist works did not take place. Where cubism attempted to do so on this occasion, decorativism prevailed, transforming its forms into a very differently oriented art deco.

Marie Rakušanová

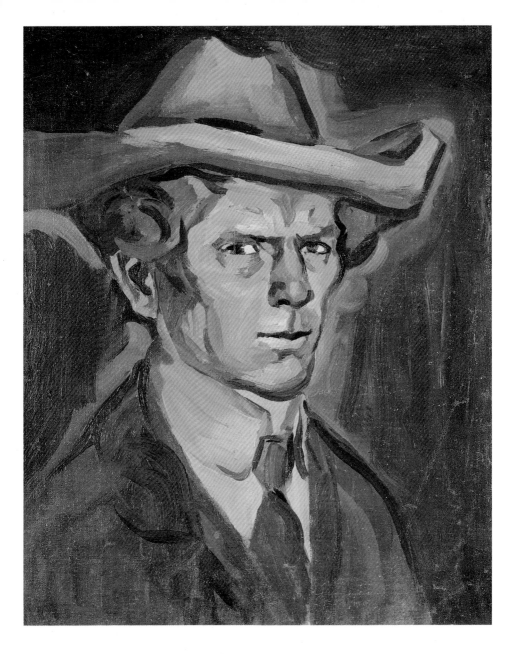

Bohumil Kubišta
(Vlčkovice 1884–1918 Prague)

Blue Self-Portrait, 1909

Oil on canvas, 51.5 × 43 cm

Unsigned

Inv. no. O 877

Purchased in 1973

In 1909, when he painted the *Blue Self-Portrait*, Bohumil Kubišta had
already participated in two exhibitions of the *Osma* (The Eight) group.
It was founded in 1907 by eight former Czech, German-Bohemian and
Jewish classmates from the Academy of Fine Arts in Prague. They were
united in an ambitious effort to break free from the provinciality of the
Prague art scene. Many of them therefore studied abroad: Kubišta, in
particular, spent six months studying in Florence (1906–07). For the same
reason, they also visited foreign museums and galleries, studying the
works of old masters and modern artists. In 1908, together with Emil Filla
and Antonín Procházka, Kubišta began to intensively study literature of
art history and the natural sciences. He focused on colour theories and
explorations of the psychological perception of colour and compositional
principles. He then verified his knowledge based on the study of scientific
treatises by applying it to the analysis of works by modern artists. The
aim was to arrive at a systematic colour and compositional solution in
his own paintings that would ensure a strong effect of the work on the
viewer. The *Blue Self-Portrait* reveals Kubišta's familiarity with colour
theories about the impact of the reversed polarity of cold and warm col-
ours. The painting is of great significance for Kubišta's further work. It
vouches his explorations of the expressive possibilities of colour and the
symbolic effects of its inner luminosity; at the same time, it foreshadows
his future interest in the construction of spatial depth and the plasticity
of volumes. These issues became central to his creative endeavours after
he had completed two stays in Paris in 1909 and 1910. The work of Nicolas
Poussin and Paul Cézanne, together with gothic art and the works of the
primitivists provided him with the impetus to think about these issues.
In 1910, when he became acquainted with the work of Pablo Picasso and
André Derain, Kubišta came to the conclusion that colour was not the
only artistic means of solving the problem of depth and volume. MR

BOHUMIL KUBIŠTA
(Vlčkovice 1884–1918 Prague)

Still Life in a Cowshed, 1910

Oil on canvas, 69 × 52 cm
Signed in the top right corner *Kubišta 1910*
Inv. no. O 383
Purchased in 1961

In 1910, Bohumil Kubišta painted several still lifes in which he explored the artistic effect of the luminous values of colours. Not only do coloured light and shadow formulate the plastic volumes of objects and the depth of space, but they also lend them magical charm and mystery. *Still Life in a Cowshed* is one of the first paintings in which the spatial effect of sharp lighting casting a precisely defined coloured shadow was explored. The renowned expert on Czech cubism Miroslav Lamač spoke in this context of 'reflective lighting', inspired by mannerist paintings. According to the Czech art historian Vojtěch Lahoda, the choice of objects (a milking stool, a milk bucket, a forage basket) typical of the poor peasant environment into which Kubišta was born has an essentially anti-cubist social element. The non-anecdotal depiction of a rural cowshed contrasts with the painting of a Parisian café painted by Kubišta a few months earlier. Lahoda also finds an emphasised rurality in Kubišta's paintings *Still Life with a Funnel* and *Still Life with a Basket*. On the other hand, Lahoda points out the formal affinity of these works by Kubišta with Pablo Picasso's proto-cubist still lifes from 1908. However, a comparison of Picasso's still life *Carafe and Three Bowls* with Kubišta's *Still Life in a Cowshed* clearly shows the differences in the concepts of the respective artists. Picasso's still life tests the ability of elementary forms inspired by African sculptures to convey spatial depth. Kubišta also reduces the shapes of objects geometrically, but by other artistic means, namely coloured light and shadow. He is inspired not only by the primitivism but also by the old masters paintings and his own study of the psychological perception of colour. Not only does he aim at an exploration of the possibilities of expressing spatial depth, but also he tries to envelop objects in magic, to reveal the mystery of the inner nature of things. Kubišta entrusted this task to the relationship of two complementary, yet mutually contrasting colours: blue-violet and ochre-green. MR

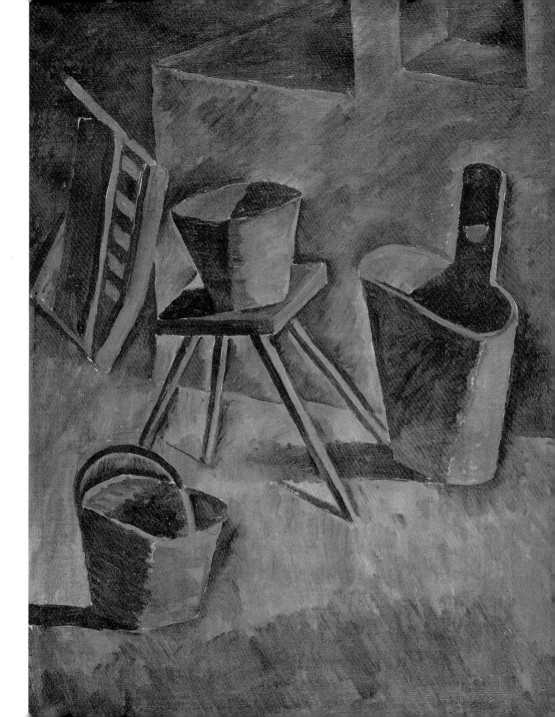

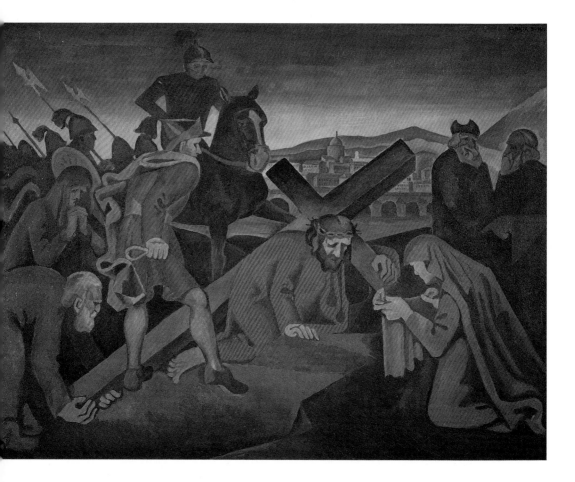

Bᴏʜᴜᴍɪʟ Kᴜʙɪšᴛᴀ
(Vlčkovice 1884–1918 Prague)

Station of the Cross (Jesus Carries His Cross), 1910

Oil on canvas, 105 × 137.5 cm

Signed in the top right corner *KUBIŠTA B 1910*

Inv. no. O 577

Purchased in 1964

The *Station of the Cross (Jesus Carries His Cross)* is the first of a series of large-scale classicising figural compositions by Bohumil Kubišta from the period of 1910–12. It was painted in the summer of 1910, shortly after Kubišta's return from his second stay in Paris. It testifies to Kubišta's intense interest in the work of the baroque painter Nicolas Poussin. In Paris, Kubišta executed a copy, or rather an artistic paraphrase, of Poussin's *Landscape with Orpheus and Eurydice.* In a 1912 study on Poussin, he addressed the painter's concept of colour and composition. The *Station of the Cross* clearly shows that Kubišta applied Poussin's colour systematics in his own works and that his compositional conception reflected his generously conceived, thought- and content-coherent construction. Kubišta painted the picture during his stay in the village of Zdechovice, where his mother and stepfather had a small farm. The inhabitants of the East Bohemia countryside were mostly from the Catholic faith, but Kubišta did not choose the subject of the painting with regard to his religion, which was based more on the values of universal spirituality. Again, he pursued mainly artistic goals. The *Station of the Cross* offered him the opportunity to realise a painting that combines the lessons of the old masters with modern forms that increased their effectiveness through simplification. Kubišta accentuates the placement of the two protagonists of the act of mercy – on the left, the scene is framed by the figure of Simon of Cyrene, helping Christ with the weight of the cross; on the right, there is St Veronica with the veil which she used to wipe Christ's face, preserving the imprint of his features. The skyline of Jerusalem looms in the background behind the cross. Kubišta emphasises the centripetal emphasis of the composition, as he places the centre of meaning – the head of Christ – at the intersection of the two diagonals of the arms of the cross; the soldiers' spears are also directed towards this focal point. The central figure of Christ has self-portrait features. Submitted to criticism, Kubišta, ascetically building the theoretical foundations of a new painting style, is the Christ carrying the cross of modern art. MR

BOHUMIL KUBIŠTA
(Vlčkovice 1884–1918 Prague)

The Judgement of Paris, 1911

Oil on canvas, 137.5 × 223 cm
Signed in the top right corner *KUBIŠTA B 1911*
Inv. no. O 333
Purchased in 1960

A monumental work of programmatic significance, *The Judgement of Paris* was created in 1911, at a time when the artist was trying to create a synthesis between classical and modern art. The ancient theme of *The Judgement of Paris*, which Kubišta chose for the largest painting he ever painted, had enjoyed a rich tradition in European painting since the Renaissance and usually was perceived as a representative piece by both artists and spectators. This seems to have been the case with Kubišta as well, although instead of exalting the traditional ideal of female beauty, he demonstrated a new formal expression of painting that deliberately suppressed the earlier aesthetic qualities of the subject depicted. Eris' apple can thus be understood here as a symbol of the struggle to promote the modern work of the emerging generation of artists. Kubišta based his painting on two renderings of the same subject by Peter Paul Rubens from 1632–35 and 1638–39, from whom he adopted the basic compositional scheme. For the overall character of the painting, however, he found support in the solid forms of Poussin's classicism, which had been rediscovered for modern art by Paul Cézanne. Kubišta also adopted the rectangular format from Poussin, whose exact proportions were determined according to geometric calculations and the principles of the golden ratio. Based on his own interpretation of Poussin, he also varied the latter's hand gestures and the dramatic twirl of their bodies. Following the example of Cézanne, he expresses himself through flat painting, deliberately distorting figures with primitivist faces and building space through complementary contrasts of colour. Kubišta set the central scene in the open air, a variation of the landscape near Prague with its rocks at Braník and the church of St Philip and St James in Zlíchov, which he had painted several times before. As a whole, the painting has a very elaborate and solid structure, which perfectly combines the distinctive rhythm of the lines, the tension of the colour surfaces and its spiritual content. It is the first work characterised by cubist morphology (albeit with fauvist and expressionist influences) to be purchased for the collection of the Gallery of West Bohemia in Pilsen in 1960. RM

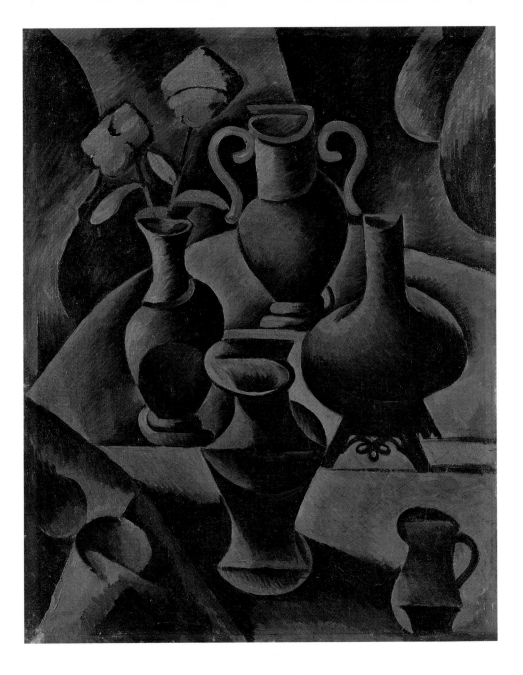

Bohumil Kubišta
(Vlčkovice 1884–1918 Prague)

Still Life with Vases, 1911

Oil on canvas, 87 × 70 cm

Unsigned

Inv. no. O 580

Purchased in 1964

In 1911, Bohumil Kubišta painted the *Still Life with Vases* together with its counterpart, *Carpenter's Still Life,* now in the collection of the private Zlatá husa gallery. The latter work is slightly smaller in size, but the paintings are very close in their overall concept. Similar to the still lifes from 1910, Kubišta limits the colour palette here to only two colours: in the *Still Life with Vases* it is the contrast of red-brown and green-black, in the *Carpenter's Still Life* it is the contrast of Parisian blue and ochre. In both paintings, Kubišta still combines two sources of light; in the *Still Life with Vases* one enters from the left side and the other, an inner illusive illumination, emanates from the surface of the shallow space. The plasticity of the objects is again modelled through coloured light and shadow. As the art historian Mahulena Nešlehová has noted, Kubišta also employed a new and refined construction procedure here. He introduced a spiral movement into the painting, emanating from the interior of the picture, adding dynamics to the entire composition. It is a winding and developing rotation, clearly applied especially in the bodies of the spatially deformed vases. Kubišta also used curves and ellipses of stereometric and planimetric projections in the following years in his figurative paintings. He made them the main means of expressing shape and time sequence, thus creating an alternative solution to cubist analysis and futurist simultaneity. It seems that Kubišta worked consciously with colour and object symbolism in both still lifes. While the 'blue' *Carpenter's Still Life* could be identified with the male element, the *Still Life with Vases* corresponds in the anthropomorphic roundness of the curves of the vases with the feminine principle, which is also reflected in the colour scale running from pink to reddish brown. The two still lifes complement each other in colour, idea and composition. The *Still Life with Vases* appeared at international exhibitions in 1912–13; Kubišta sent it together with six other paintings to the Berlin *Neue Secession* exhibition in December 1912, from where it was sent to exhibitions in Budapest and Lviv in 1913. MR

Bohumil Kubišta
(Vlčkovice 1884–1918 Prague)

The Resurrection of Lazarus, 1911–12

Oil on canvas, 163.5 × 126.5 cm

Signed in the top right corner *B. Kubišta 1911–1912*

Inv. no. O 380

Purchased in 1961

At the beginning of 1912, Bohumil Kubišta completed his series of large, multi-figure compositions with the painting titled *The Resurrection of Lazarus.* In it, at the same time, he made a formal progress from the classicising rounded shapes of figures, characteristic of his previous paintings, to cubist-stylised figures and crystalline backgrounds. After the painting of *Station of the Cross (Jesus Carries His Cross)*, Kubišta again turned to the New Testament motif, namely to Christ's miracle of the resurrection of the dead Lazarus, as recorded in the Gospel of John. In Kubišta's painting, Christ is standing surrounded by a crowd of people inside a rock tomb. Lazarus is rising from the grave, freeing himself from the shroud. The central group also includes Lazarus' sisters: Mary, lowly kneeling, and Martha, watching in disbelief as her brother's body is revived. The figure of Christ raises his right hand in an imperative gesture, the left is extended over Lazarus. The enigmatic moment of the resurrection is depicted. Christ has just spoken the words: 'Lazarus, come out!'

The iconographic motif of the Resurrection of Lazarus occurred sporadically in modern art. The detail of Rembrandt's engraving of the Resurrection of Lazarus from 1632 was copied by Vincent van Gogh, and Kubišta also refers, albeit obliquely, to the work of the former – specifically to the engraving from 1642, from which he took the basic layout of the miraculous scene inside the cave overlooking the open landscape with the architectural landmark of Bethany. Kubišta, however, combined this impulse with inspiration from other works by Nicolas Poussin and Titian. Kubišta's stylisation of Christ and some other figures was most strongly influenced by the work of the mannerist painter El Greco. Christ's dynamic posture and gestures may have been inspired by El Greco's painting *Christ Driving the Traders from the Temple*, while the condensed, rhombic form of Christ's garment, with the sharp breaks in the drapery, reminds us of the Christ from *The Disrobing of Christ.* The ecstatic nature of El Greco's

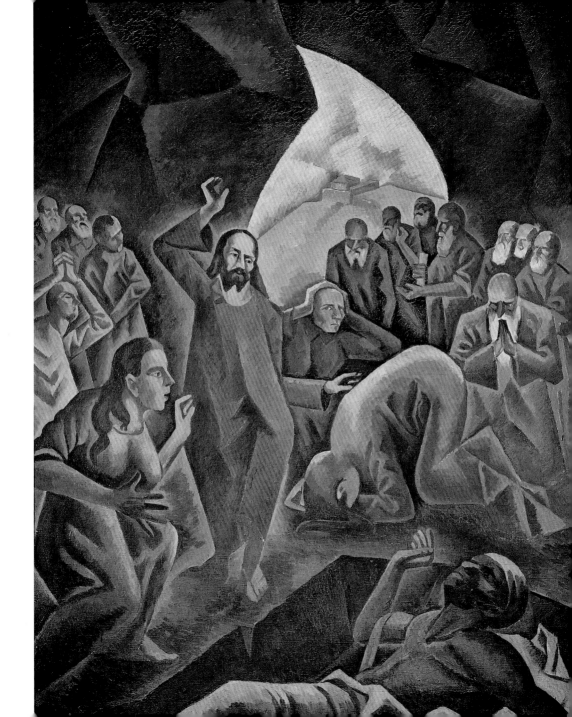

visions, imbued with the mysticism of his luminous concept and the symbolism of colour and shape distortions, was in keeping with the programme of Kubišta's work. According to the Gospel of John, Christ said to Lazarus' doubting sister Martha, 'I am the resurrection and the life'. Kubišta inserted this message into the basic layout of the figural composition, based on the pentagon, traditionally symbolising life-giving energy. As the art historian Mahulena Nešlehová has noted, the pentagon was already prominently used in the sketches, and by expanding it in the final painting Kubišta brought together all five key figures of the miracle and their gestures: Christ, Lazarus, Mary, Martha and the kneeling man, holding his head in his hands and looking directly at the viewer. This enigmatic figure, situated in the centre of the painting, has self-portrait features; this kneeling witness shields his hearing from Jesus' deafening life-giving command, but at the same time his facial expression testifies to a spiritual (specifically creative) epiphany.

The Resurrection of Lazarus was painted on canvas which Kubišta had already used in 1908 to paint the scene of the promenade in Rieger Park. It is the case of many of Kubišta's works that they have an older painting on the reverse, often painted over by the artist. Throughout his life, Kubišta struggled with a lack of materials which, among other things, forced him to reuse his canvases. Also on the reverse of the *Station of the Cross*, an indistinct motif of a promenade can be found. The reverse side of the painting *At Our Yard* from the National Gallery in Prague features, in terms of movement, the most conceptually sophisticated and dynamic representation of this 'promenade' theme. All these paintings were made in the same year and reflect Kubišta's fascination with the work of Edvard Munch, who played a fundamental role in the early development of the members of the Osma group. Munch's lesson resonates both in the choice of subject (his *Evening on Karl Johan Street*, from 1892, which depicts a large crowd of townsfolk suggestively gazing at the viewer, was exhibited in 1905 at a major exhibition of the artist in Prague) and in the distortion of forms. The paintings are characterised by distinctive colouring. The figures are treated in a single shade, similar to Kubišta's *Blue Self-Portrait*. MR

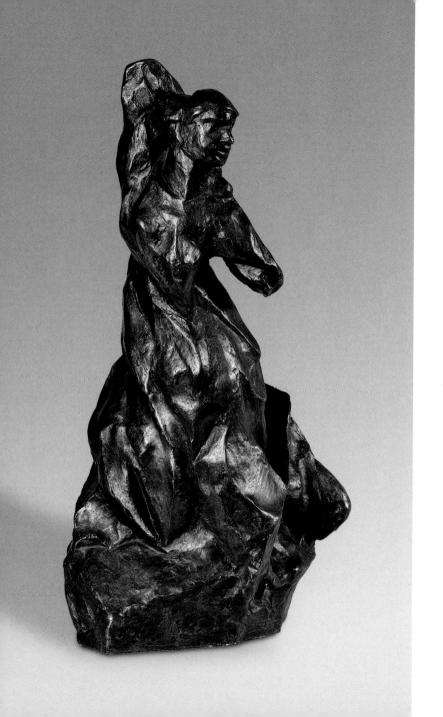

OTTO GUTFREUND
(Dvůr Králové nad Labem 1889–1927 Prague)

Dressing, 1911

Bronze, H. 43 cm, W. 23 cm, D. 16 cm

Signed bottom right with an engraved letter 'G'

Inv. no. P 154

Purchased in 1970

Otto Gutfreund is the most prominent Czech sculptor of the first third of the twentieth century; his independent journey towards modern sculpture is unique not only in the Czech context, but also in the wider European scale. Gutfreund received his first major artistic impulses in Paris in the studio of Antoine Bourdelle, whom he visited between 1909 and 1910, and after his return to Prague he became one of the main representatives of cubism. In 1916, his original thinking about the concept of dematerialised sculpture brought him to the brink of abstraction. The sculpture *Dressing* from 1911 still belongs to the sculptor's early period. It is a merger of the cubist segmentation of the sculpture's surface and the expressive 'right to deformation', which was defended by art historian Antonín Matějček in connection with the exhibition of modern French art in Prague (*Les Indépendants*, 1910). He expressed his opposition to naturalistic copying of reality and defended modern artistic expression. This is what Gutfreund also tended towards, and *Dressing* clearly confirms this inclination towards a new artistic expression. The sculpture consists of a dynamically modelled drapery; its whole gives the impression of rotational movement, the dynamics completed by the diagonal gesture of the hands joined behind the back. An imaginary spiral unfolds from the lower right edge to the elbow of the upraised hand. The surface is dynamically decorated with various sharp indentations and protruding edges, which disrupt the compactness of the sculpture's mass and support the dominant impression of rotation around the vertical axis. Although the sculpture is not one of Otto Gutfreund's large works, it is one of his first significant pieces. He included it in the first exhibition of the Group of Fine Artists in Prague (January–February 1912) and in the later exhibition of the Group in the Berlin Der Sturm gallery in October 1913. AP

OTTO GUTFREUND
(Dvůr Králové nad Labem 1889–1927 Prague)

Anxiety, 1911–12

Bronze, H. 148 cm, W. 50 cm, D. 50 cm
Unsigned
Inv. no. P 147
Purchased in 1968

The sculpture *Anxiety* is the culmination of Gutfreund's cubo-expressionist phase, which is still dominated by a strongly modelled and deeply refracted mass. According to Gutfreund, however, the sculpture was not solely to represent a new form, but to have a spiritual, symbolic meaning. Its true meaning was to convey an abstract idea, embodied in a material form (a sculpture), to the viewer. In this case, the tense inner state is represented as a female figure, huddled in as though to defend herself against the outside world. She is veiled in a drapery, the surface of which is expressively broken by deep cuts and made dramatic by sharp edges. The crystalline form refers to both cubist fragmentation and expressionist shape distortions, representing a kind of violation of the material. The superimposed verticality and the impression of upward ascent are evoked by the interconnection of the drapery and the plinth, which, like the drapery, is expressively rugged. *Anxiety* expressed the consciousness of the contemporary generation and became one of Otto Gutfreund's most famous sculptures. It was featured in the first exhibition of the Group of Fine Artists in Prague (January–February 1912), and then in the Group's exhibition at Hans Goltz's Neue Kunst Salon in Munich (April 1913). Over the following years, Gutfreund abandoned this expressionist approach and associated existential themes, also initiated by the work of Edvard Munch (Prague exhibition in 1905). Instead of the dramatic modelling of a compact matter, he came to prefer statues that were clear and logical in their construction. At that time he was also working on a ground-breaking theoretical concept of modern sculpture, based on a composition of dematerialised shapes and surfaces, where volume is evoked by a virtual movement. This innovative concept, based on dynamic perception, clearly goes beyond contemporary thinking about the principles of modern sculpture. AP

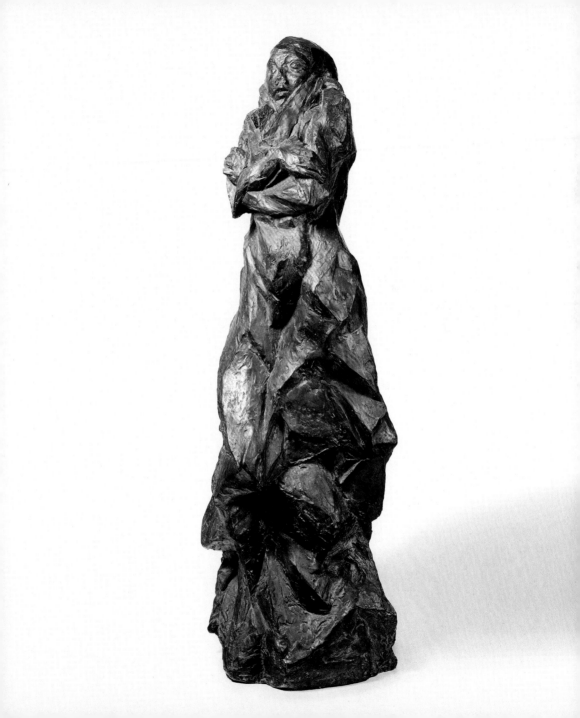

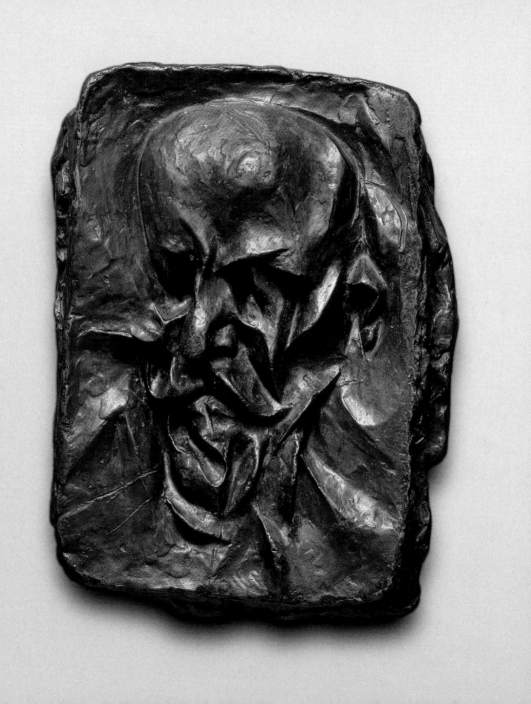

OTTO GUTFREUND
(Dvůr Králové nad Labem 1889–1927 Prague)

Portrait of Father III, 1912

Relief, bronze, 40 × 28 cm
Unsigned
Inv. no. P 158
Purchased in 1971

At the beginning of Gutfreund's oeuvre there are reflections on reliefs, which are related to the artist's concept of modern sculpture at that time. It was not meant to be an imitation of reality, a naturalistic transcription of it, but to have its own laws independent of reality. Gutfreund thus joins the views of modern artists striving for an autonomous work of art arising from the creative will. Not only did he find confirmation of his views in his own analyses of older artworks (he wrote, for example, about gothic tiles), but he also studied theoretical literature for guidance. In particular, he found support in Wilhelm Worringer's *Abstraction et Einfühlung* (1908), which placed stylisation and abstraction on an equal footing with realism. In the case of a relief, the abstraction lies in the form itself, which suppresses three-dimensionality and weight but, unlike a painting, which is close to flatness, contains real space. In the *Portrait of Father*, this is manifested by the sharply dynamised pointed notches contrasting with the curve of the protruding forehead. The edges of the relief also rise into the foreground, bringing the relief back to a single flat plane. This third version of the depiction of the father still retains the likeness of the sitter, unlike the following version of the relief, where the physiognomy of the head is no longer distinguishable; it disappears in the spiralling swirl of the edges, and we do not know whether it is a likeness of the father, a self-portrait, or just a facial motif. This proves, among other things, that Gutfreund abandoned the subject of portraiture at that time, seeing it as too tied to the reproduction of a concrete reality. He would continue to give preference to subjects that carried a more general idea. AP

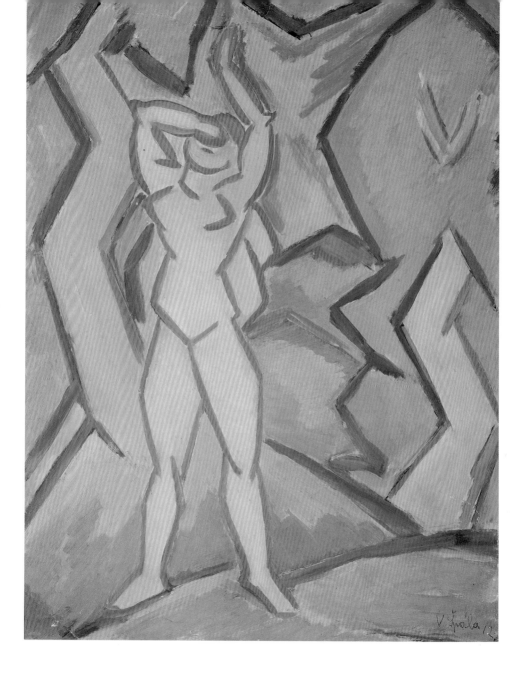

Václav Špála
(Žlunice near Nový Bydžov 1885–1946 Prague)

Nude Girl (In Her Prime), 1912

Oil, canvas, 66 × 51 cm
Signed in pencil in the bottom right corner *V Špála 12*
Inv. no. O 903
Purchased in 1973

The painting *Nude Girl (In Her Prime)* by Václav Špála depicts a nude
female figure in a straddled posture, her head turned towards the sun,
from which she covers her eyes. The figure is integrated into a natural
frame among the trunks and tree tops with a glimmering blue sky. The
sensuous, fauvist painting, executed in brightly coloured surfaces, applies
the cubist morphology of jagged zigzags, creating sharp edges of volumes
which the artist enhances with a coloured contour. Špála's concept of
the image, built on the reduction of mass and geometrisation of shapes,
resonates with contemporary Czech cubist sculpture and architecture.
Špála's work echoes both the vitalist concept of perceiving the world and
nature, but also the related naturalism, which from the turn of the twen-
tieth century – as part of the *Lebensreform* of the German social reform
movements – also affected the visual arts. The painting was created at the
same time as Špála's multi-figure painting *Bathing*. It indicates his further
inclination towards the frequent theme of rural women painted in the
national colours of the tricolour: red, blue and white. In this case, too, it
was confirmed that Špála was an intuitive artist, expressing himself with
unmistakable immediacy through his expressive painterly gesture. RM

VÁCLAV ŠPÁLA
(Žlunice near Nový Bydžov 1885–1946 Prague 1946)

Bathing, 1912

Oil, canvas, 63 × 79 cm
Signed in the bottom right corner *V Špála 12*
Inv. no. O 708
Purchased in 1967

The painting *Bathing* from 1912 occupies an important place in the early work of Václav Špála. It represents a transition from the artist's fauvist period towards his distinctive interpretation of cubism, later expressed in a geometric reduction of form, energetic and strongly faceted painting, together with the use of a basic colour palette reduced to tones of red, blue and white. The painting is characterised by a solid construction; the space is built up by the rhythm of lines, formed by tree trunks and female bodies with puppet-like motoric movements. An important inspiration for Špála was André Derain's painting *Bathing Women* (1908), which he was able to see at the Prague exhibition of French art *Les Indépendents*, organised by the *Mánes* society of fine artists in 1910. An equally important prefigurement for the creation of his own work was Paul Cézanne's *Bathers* (1906). From both artists, Špála adopted the primitivist style of painting and the typology of elongated figures set in a natural setting of an open-air frame; from Cézanne, quite specifically, the standing female figure with long hair leaning towards the centre of the painting on the left part of the canvas, as well as the pyramidal composition. In addition to the aforementioned exhibition, Špála had the opportunity to get acquainted with the works of both the above-mentioned artists during his stay in Paris, which took place a year before the creation of his *Bathing*. Špála first exhibited his painting at the second exhibition of the Group of Fine Artists, which took place in the autumn of 1912 at the Municipal House in Prague. Špála often revisited the theme of bathing in his work during the second decade of the twentieth century. He specifically marked this painting in his handwritten inventory of the work with three slashes, which, according to his classification, indicated 'prima rare'. From the turn of the twentieth century, the theme of bathing played a significant role in modern European art, providing an opportunity to address current problems of a new concept of figurative painting. Its treatment can also be found in several of Špála's contemporaries of the same generation associated with the emerging cubism. RM

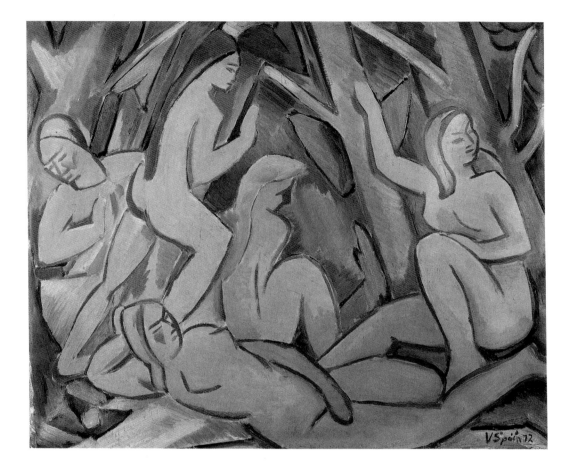

BOHUMIL KUBIŠTA
(Vlčkovice 1884–1918 Prague)

Studio, 1912

Oil, canvas, 51.5 × 41.5 cm

Signed in the top right corner *B. Kubišta 1912*

Inv. no. O 377

Purchased in 1961

The painting *Studio* was painted by Bohumil Kubišta in the autumn of 1912, apparently shortly after moving into his new studio in Opatovická Street in Prague. The work occupies a special position in the context of Kubišta's works from 1912. In that year, he painted *St. Sebastian, Kiss of Death, The Hypnotist* and *Murder,* which are characterised by thematic symbolism and the psychologism of exacerbated inner states. The factual and civil subject of *Studio* stands out from this layer of Kubišta's work. Here, the spatial geometric projections are employed in a different way by the artist. They continue to be the basic predisposition of the whole work, but they do not convey symbolic contents. In *Studio,* they provide a means for exploration of a new type of pictorial representation. Kubišta's experiment, however, has little in common with Picasso's rethinking of the representational tradition of Western painting. Kubišta's *Studio* engages in a rather polemical dialogue with Picasso's analytical cubist still lifes of 1912. In the painting, Kubišta placed a transparent oval in front of a set of objects. Until now, the previous interpreters of the image have assumed that it is a mirror; but the mirror reflection is not thematised in any way. Thus the possibility that Kubišta's oval alludes to the pictorial format then favoured by Picasso can be raised, as Kubišta was familiar with Picasso's oval paintings. The play with the arbitrariness of signs was characteristic of these high cubist compositions, of which Kubišta, as a serious seeker of a new type of pictorial representation, had no understanding. He could not possibly admit that Picasso's ironic juggling with the viewer's demands for legibility of representation could be intentional. He criticised it by placing an ostentatiously autotelic oval in front of the composition of *Studio,* which also polemicises with Picasso's works in other layers of representation. Against Picasso's condensing of the image with alienated details, Kubišta defines himself by the clear organisation of objects in spatially complex situations. MR

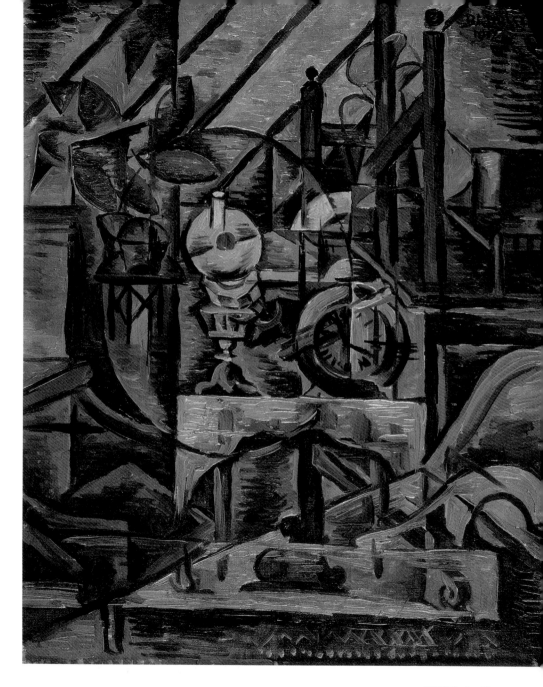

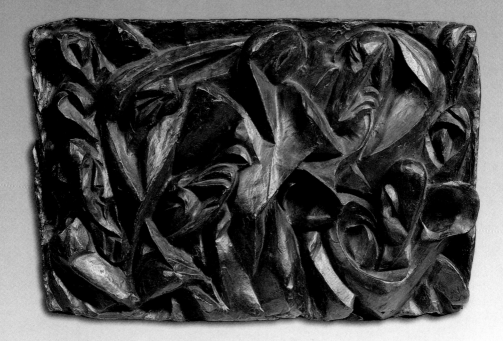

OTTO GUTFREUND
(Dvůr Králové nad Labem 1889–1927 Prague)

Concert, 1912–13

Relief, bronze, 44 × 68 cm
Unsigned
Inv. no. P 163
Purchased in 1975

Music, as a symbol of abstract expression, independent of reality, became a strong stimulus for the art of the time and Gutfreund, in addition to the relief *Concert* and the figure of a *Cellist*, also devoted himself to it in a series of drawings. Apart from the subjects of the musicians themselves, the temporal dimension of the music and its rhythm was essential for the sculptor. The drawing *Dancing* (1913) comes closest to the dynamic experience of music. In it, Gutfreund uses sharper contrasts between light and dark segments, as if he were seeking to evoke musical rhythm through visual means. He wanted to express the same thing in a relief, which Gutfreund understood as an agitated 'surface that undulates and overlaps'. In *Concert*, this understanding is expressed by alternating between countersunk and protruding parts, which strongly absorb and reflect the light falling on their surfaces. The outline is almost unrecognisable; only in the middle section does the figure of the conductor emerge in the rough contours. The relief ceases to be a representation and becomes a dynamic composition of geometrised concave and convex forms. Shapes collide and permeate, the main theme becomes rhythm and movement – something that would later be a key moment in Gutfreund's rethinking of the concept of open, dematerialised sculpture. The relief was perhaps the most frequently exhibited of Gutfreund's sculptures; along with three other Gutfreund sculptures, it could also be seen at the *Erster Deutscher Herbstsalon* in Berlin (September–October 1913); simultaneously, a cast was displayed in a set of six sculptures at the Group of Fine Artists' exhibition at Herwarth Walden's *Galerie Der Sturm* (October 1913); and then again at the *Verein LIA* exhibition in Leipzig (January–February 1914). In Prague, it was included in the fourth exhibition of the Group of Fine Artists (February–March 1914). AP

OTTO GUTFREUND
(Dvůr Králové nad Labem 1889–1927 Prague)

Hamlet II, 1912–13

Sculpture, bronze, H. 68 cm, W. 19 cm, D. 16 cm
Unsigned
Inv. no. P 144
Purchased in 1967

In the early period of his work, Gutfreund used relief very often, but this was only the beginning of his search for a dematerialised sculpture. Later, he asked himself how to reduce the weight of free sculpture while maintaining its spatiality. What certainly played a role in this process was the constantly emphasised comparison of sculpture with the processes of painting, which succeeded in removing what had bound it to the previous concept of painting: the perspective, the illusion of space. Space in sculpture was not the main issue, as it is a natural property of the medium; the problem was the weight associated with naturalism. In his search for a solution, Gutfreund turned to old art, this time to Donatello's *St John the Baptist* from the duomo of Siena. Observing the rotation of the arms, the shoulder and the legs, he noted that the sculpture is created for a single-angle view, much as we look at a relief. An inspiration closer in time is Honoré Daumier, praised by Czech modern artists. Gutfreund saw his expressive sculpture *Ratapoil* (*c.* 1851) at an exhibition in Berlin in 1912. In a review published in the *Art Monthly* magazine, Gutfreund praised especially its luminous qualities and its reduction of volume to lines. This was also what he wanted to achieve in his *Hamlet* sculpture. He first sketched his figure as drawings; while the first of them is still influenced by the idea of a costumed actor on a theatre stage, the subsequent one suppresses this descriptiveness. He also created the sculpture in two versions; the finalised work then stemmed from the second version, resulting in a torso, in which he removed the distracting physical gesture of the hands. It depicts a dematerialised, distinctly vertical figure with the right leg put forward. The torso and head do not follow the direction of the step but turn to the frontal view, towards the viewer. The result is a loose sculpture, but conceived according to the principle of relief; the dominant feature is the optically conceived surface, which is 'a form of abstracted volume'. The work was exhibited at the fourth exhibition of the Group of Fine Artists in Prague (February–March 1914). AP

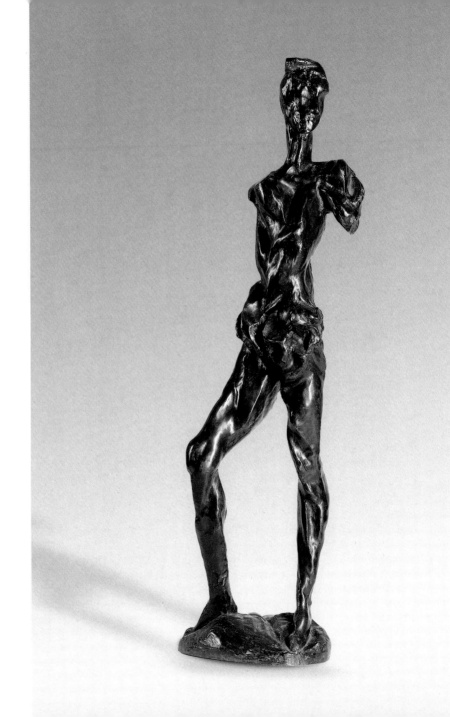

JAN ZRZAVÝ
(Okrouhlice 1890–1977 Prague)

Sleepwalker, 1913

Oil on canvas and plywood, 79.5 × 44 cm
Unsigned
Inv. no. O 1002
Purchased in 1978

Jan Zrzavý was a distinctive figure in Czech art of the first third of the twentieth century. Although his savagely expressive works from the beginning of the first decade of the twentieth century are similar in style to the work of the emerging generation of young painters centred around the Osma group, he soon abandoned their formal innovations, never accepted the analytical decomposition of objects, and turned instead to compact simplified painting, to which he remained faithful in later years. He worked outside the circle of cubists, of whom he was close friends only with Bohumil Kubišta, who introduced him to his concept of the representation of space and volumes on the surface. Zrzavý also used partial motifs inspired by Kubišta in some of his paintings (*Still Life with Lilies of the Valley,* 1913). Throughout his creative activity, however, he was primarily concerned with the spiritualisation of art, the symbolic hidden behind things and the representation of inner visions. In this, he eventually found a kindred spirit in Giorgio de Chirico, whose metaphysical approach to painting, created in parallel with cubism, was very close to Zrzavý's heart. Giorgio de Chirico also wrote a text about Jan Zrzavý in the mid-1930s, in which he speaks admiringly of the magic of the latter's paintings and compares them to Italian primitivists. Mystery also emanates from the 1913 painting *Sleepwalker,* an almost monochrome painting in green-blue tones with a phantom faceless figure balancing on top of a sloping roof. The moonlight plastically shapes the figure, clearly drawn against the background of the stylised towers of the dream city and the dark sky. Only the sharp angles of the roofs and the buildings composed of cones and cylinders remind us of the cubist geometrisation. However, form is not the priority here; Zrzavý was concerned with conveying the magic of the moonlit night; in the figure of the sleepwalker he has objectified the mysterious powers of the full moon and the altered state of consciousness. He thus continued the tradition of symbolism and transposed it, albeit in new forms, on to the modern art of the twentieth century. AP

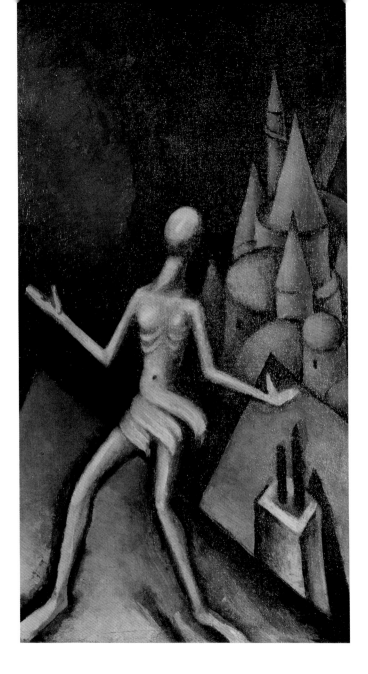

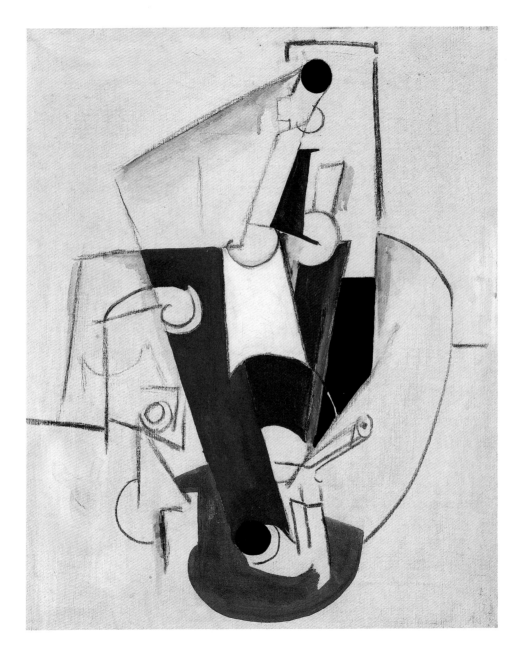

EMIL FILLA
(Chropyně 1882–1953 Prague)

Bottle, Glass and Pipe, 1913

Oil and charcoal on canvas, 51 × 42 cm

Signed in the centre on the reverse *E. Filla 13*

Inv. no. O 1017

Purchased in 1979

One of the leading figures in Czech cubism, Emil Filla was not only a painter but also a very active organiser of events and chronicler of artistic life. He joined the circle of artists gathered around the art historian and critic Vincenc Kramář, who at the time recognised only the work of Pablo Picasso and Georges Braque in modern art. This is proved by his unique collection of French cubism acquired between 1911 and 1914, which became a mainstay for painters such as Emil Filla. In the early 1910s he combined a variety of influences in his work, such as biblical themes and compositions inspired by El Greco, later starting to incorporate broken lines and geometrical shapes derived from early cubism. Shortly afterwards Filla abandoned the biblical or allegorical themes and embraced the pure art of Picasso's cubism fully, for which he was immediately criticised. His strong position, however, stemmed from an unwavering belief in the revolutionary significance of Picasso's artistic philosophy. He perceived it as the most advanced version of all contemporary approaches to the non-imitative depiction of reality and saw it, however erroneously, as the key to the future of the new art of the modern era. According to Filla, creative work was supposed to develop and build on this version of art, not change or water it down with 'unnecessary' innovations. In this spirit he expounded his views forcefully. The still life known as *Bottle, Glass and Pipe* was a break from his series of dark-coloured paintings and newly combined painting with light charcoal drawing. It seems to have been inspired by cubist collage – Filla probably saw a reproduction of Picasso's painting *Bottle and Glass* from 1913 with pieces of newspaper glued onto it. More than the radical nature of the technique, however, it was the formal appearance of the collage that attracted him; to Filla it was convenient to incorporate its principles into painting. Collage as a technique, for that matter, was not widely accepted in Czech art at that time; it featured only as a marginal artistic expression. Nevertheless, Filla adopted its visual appearance – in his 'version', there is a significant simplification of artistic technique and only flat, monochromatic shapes and lines are combined on the pale surface, enhancing its formal aspects and brightening its composition. Unlike Picasso the Experimenter, he remained Filla the Painter. AP

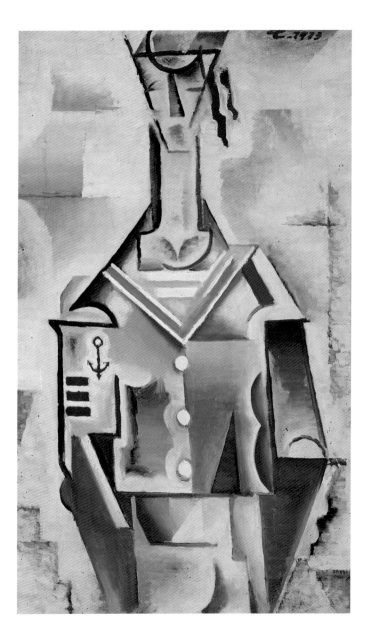

JOSEF ČAPEK
(Hronov 1887–1945 Bergen-Belsen Concentration Camp, Germany)

Sailor, 1913

Oil on canvas, 90.5 × 55.5 cm
Signed in the top right corner *Č. 1913*
Inv. č. O 809
Purchased in 1970

Just as the art scene in Paris was divided into artists promoted by the influential painting dealer Daniel-Henry Kahnweiler (Picasso, Braque) and others who referred to themselves as the 'Puteaux Group' or the 'salon cubists' (i.e. those who exhibited at the regular salons, such as Albert Gleizes, Jean Metzinger, Robert Delaunay, etc.), the cubists in Prague also split. Alongside the 'Picassist' painters Filla and Beneš, painters striving for variant paths (Kubišta, Čapek, Špála, etc.) asserted themselves. Although Josef Čapek became acquainted with Picasso's works during his stays in Paris (1909–10 and 1912), he did not identify himself with the analytical decomposition of shapes, although he tried out its forms in several paintings. Čapek's distinctive painting style was shaped in around 1913. It is characterised by the composition of partial geometric shapes, often very simple. Čapek conceived his paintings according to the principle of the 'economy of form', which caught his attention while studying primitivist art in Paris. His figurative compositions consist of a frontally depicted figure or half-figure as if assembled from flat building blocks, typically with distinctive outlines, symmetries or telling attributes – in this case the ribbon on the sailor's cap, the triangular collar and the anchor on the sleeve. Čapek revisited the theme of the sailor, which symbolised his desire for adventurous travel and exotic distances, several times in his work, both in paintings and drawings. The painting from the Gallery of West Bohemia in Pilsen marks the beginning of this thematic series culminating in 1917; the reduction and regular composition of basic shapes is not yet so consistent, but its starting points are already clearly present both in the composition and colour. As an example of alternative artistic approaches, the *Sailor* was selected for the Czech collection of the international *Modern Art* exhibition organised in Prague by the French art critic Alexandre Mercereau in 1914. This exhibition presented current tendencies of modern art different from Picasso's solution (works of Alexander Archipenko, Robert Delaunay, Constantin Brâncuși, Albert Gleizes, Raymond Duchamp-Villon and others). AP

Bohumil Kubišta
(Vlčkovice 1884–1918 Prague)

Sailor, 1913

Oil on canvas, 49.5 × 37.5 cm

Signed in the top right corner (partly overpainted) *ISTA 13*

Inv. no. O 810

Purchased in 1970

In the spring of 1913, Bohumil Kubišta enlisted in the Austro-Hungarian army for financial reasons and in October he was assigned to the Fourth Fortress Artillery Regiment in Pula, where he remained until the end of the war. There was little time for artistic activity, yet during his time in Pula he produced, alongside more traditional paintings, several works that depict the situation in progressive forms. The sailor belonged to the crew of the famous battleship of the Austro-Hungarian Navy *Viribus Unitis*, as we learn from the inscription on the sailor's cap; it is a portrait created according to a geometric order and at the same time applying the idea of the simultaneity of different moments in time. Kubišta deliberately wanted to distinguish himself from Picasso's cubism, which was dominantly promoted in Prague, especially by Vincenc Kramář and through the *Art Monthly* magazine. He was looking for different ways to express himself; so it is not surprising that he took his cues from a wider range of ideas that were current at the time. Among others, he was interested in the theories of the French philosopher Henri Bergson, which also appealed to the futurists, the Czech painter František Kupka, who was based in Paris, and the French cubists of the Puteaux Group. Bergson focused on the issues of the continuous passage of time, duration and memory, on the dynamic concept of life and of the world. Kubišta understood the question of time in painting not as a linear sequence, but as a spatial layering and simultaneous overlapping of differently recorded views. The guide for their interpretation is a geometric outline, along whose lines the partial views are formed, as can be seen in his *Sailor*. In addition to the vertical axis running through the centre of the sailor's face, there is also a diagonal axis determining a different spatial angle, followed by other perpendicular and diagonal lines guiding the viewer's sight through the image. The painting is thus a system of various interpenetrating visual sensations held in memory. It was exhibited at the sixth *Neue Secession* exhibition at the Neue Galerie in Berlin (December 1913). AP

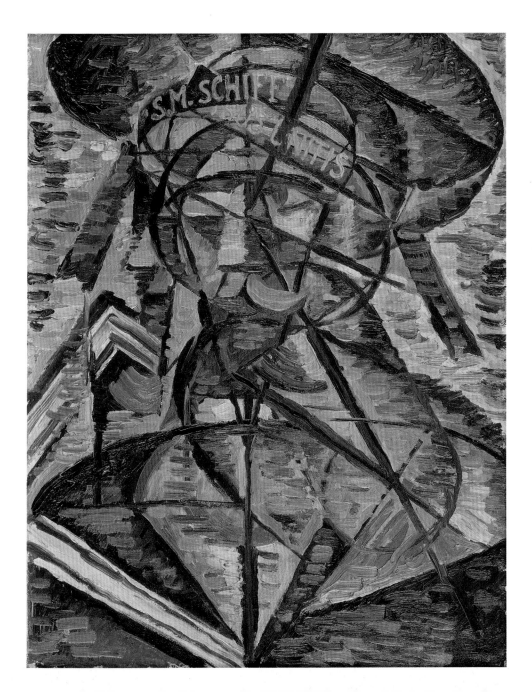

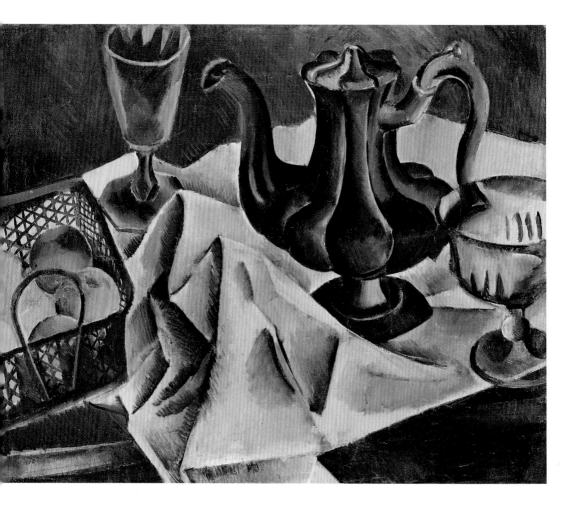

Jiří (Georges) Kars
(Kralupy nad Vltavou 1880–1945 Geneva, Switzerland)

Still Life with a Green Glass, 1914

Oil on canvas, 52 × 65 cm

Signed in the top left corner *Kars 14*

Inv. no. O 1495

Purchased in 2009

Jiří (also Georg or Georges) Kars came from a rich Jewish, German-speaking family from Bohemia. From 1899, he studied at the Munich Academy. He returned briefly to Prague in 1905 and then stayed in Madrid until 1907, where he met the painter Juan Gris. In 1908, Kars settled in Montmartre. There he maintained contact with many modern artists and art critics. From 1910 to 1913, he participated in the *Salon d'Automne*, and in 1911 he exhibited there in Hall 8 alongside Jean Metzinger, Albert Gleizes, Fernand Léger and others. This presentation is considered one of the first joint cubist exhibitions. In one of his articles on cubism, Guillaume Apollinaire distinguished between representatives of 'pure' cubism and artists who adopted cubism on more intuitive grounds. It is no surprise that he included Kars, who never fully embraced the cubist style, in the second group; the reason for this is seen in the *Still Life with a Green Glass*. The painting originated in 1914, apparently shortly after the outbreak of the First World War. As a citizen of the Austro-Hungarian Empire, i.e. an enemy country, Kars had to leave Paris in a hurry and return to Prague. In addition to the painting in the collection of the Gallery of West Bohemia, he painted a still life with a similar layout and almost identical dimensions, now in the collection of the National Gallery in Prague. The concept of both still lifes clearly reflects the experience Kars gained during his years in Paris. In particular, he was interested in the work of artists such as André Derain and Othon Friesz, who specifically reflected on the legacy of Paul Cézanne, independent of the cubism of Picasso and Braque. Kars addressed the role of colour tone as a building block and explores the malleable possibilities of the tonal value. However, his colour palette is dull, as if clouded, which is characteristic of the underlying melancholic tonality of his painting. Only lightly does Kars touch on the question of cubist multi-perspectivism in the painting under review. MR

EMIL FILLA
(Chropyně 1882–1953 Prague)

Still Life with Bols, 1914

Oil on canvas, 30.5 × 46 cm

Signed in the centre on the reverse *E. Filla 14*

Inv. no. O 633

Purchased in 1966

The beginning of the First World War stranded Emil Filla in Paris, where he had come for a longer stay with his wife Hana in the summer of 1914. Under dramatic circumstances, the couple had to separate and Filla headed for Rotterdam, in the Netherlands. He remained there until the spring of 1915, when he was joined by his wife, with whom he moved to Amsterdam. In the *Still Life with Bols* from 1914, Filla used a characteristic inscription fragment referring to the Dutch liqueur, which had been popular also with Parisian café-goers in the years before the First World War. The art historian Vojtěch Lahoda has emphasised Filla's independence of Picasso's model in the case of this painting. However, he compared this still life primarily to Picasso's work of 1914, with its playful manner using dots, frequent use of collage and the decorative style of 'rococo cubism'. In fact, Filla's painting has nothing in common with this, but it is interesting to compare it with Picasso's works from late 1912. At that time, along with his first synthetic cubist collages, Picasso was also creating works in which he imitated collage elements – newspaper clippings, pasted labels, pieces of paper and wallpaper – by means of drawing or oil painting. He created the illusion of the texture of various materials pasted on paper or canvas with structurally richer areas of paint, and achieved the impression of collage layering with planes placed one over another. In Filla's *Still Life with Bols,* we encounter all of these strategies, translating the sign nature of collage into the traditional medium of painting. Two other works are related to the painting from the Gallery of West Bohemia in Pilsen: the painting *Glasses* (1914) from the Zlatá husa gallery and *Bottle of Bols* (1915) from the National Gallery in Prague. The popular drink Bols connects all three of these works in terms of motif, but both the *Glasses* and *Bottle of Bols* are painted more expressively and are more closely related to other works of Filla's Dutch period. This fact suggests the possibility that *Still Life with Bols* had been painted before Filla's departure from Paris. MR

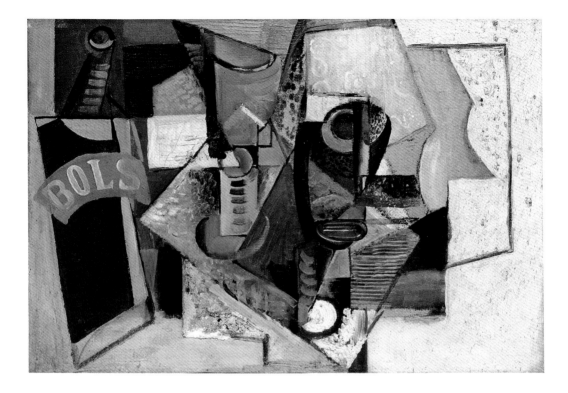

EMIL FILLA
(Chropyně 1882–1953 Prague)

Head of an Old Man, 1914

Oil on canvas, 66.5 × 50 cm

Signed in the centre on the reverse *Emil Filla/Rotterdam 14*

Inv. no. O 632

Purchased in 1966

This painting is an excellent example of Filla's climax as a cubist and was painted during his stay in Rotterdam in 1914. Vojtěch Lahoda, a prominent expert on Filla's work, speculated whether this painting in fact represented a portrait of Comenius, a Moravian Protestant educator and theologian who lived in exile in the Netherlands in the seventeenth century. It would stand to reason, as during the war years, Filla showed a great interest in the work of his famous compatriot. The painting could thus be seen as a manifestation of Filla's 'crypto-nationalism'. Lahoda rightly compared the old man's head to Picasso's painting *The Poet* from 1912. The latter was undoubtedly well known to Filla from Kahnweiler's Parisian shop. In the *Head of an Old Man*, Filla repeated the basic composition of the head from Picasso's *The Poet*, describing an obliquely composed triangle whose lower angle merges with the beard. On the other hand, the pointed moustache and beard in Picasso's *The Poet* are replaced in Filla's painting by curly strokes of a comb in the paint. Lahoda also emphasises other differences: Filla, he said, layers the paint on the fine canvas in a very neat manner and his painting is subtly more transparent than Picasso's. Overall, Filla's painting is lighter, less punchy and eruptive. Moreover, the shape construction of the two respective works also have a different basis. In the case of Picasso's *The Poet* it is a vertical plane, formulating the layout of the face and anchoring the (surprisingly almost symmetrical) nose and moustache in a firm compositional manner. In the *Head of an Old Man* the same role is played by a diagonal plane, which makes the coherence of the facial features less rigid. The basic diagonal layout brings Filla's painting closer to Kubišta's *Sailor*, executed a year earlier in Pula. However, Kubišta plays out a dynamic movement around the diagonal axis that fundamentally distinguishes the two works from each other. Lahoda was aware of the extraordinary proximity of Filla's and Picasso's works, despite the differences that he found. He reflected on the term 'epigonism', which is often used to describe the relationship between the two, but he considered Filla more as a successor to Picasso. MR

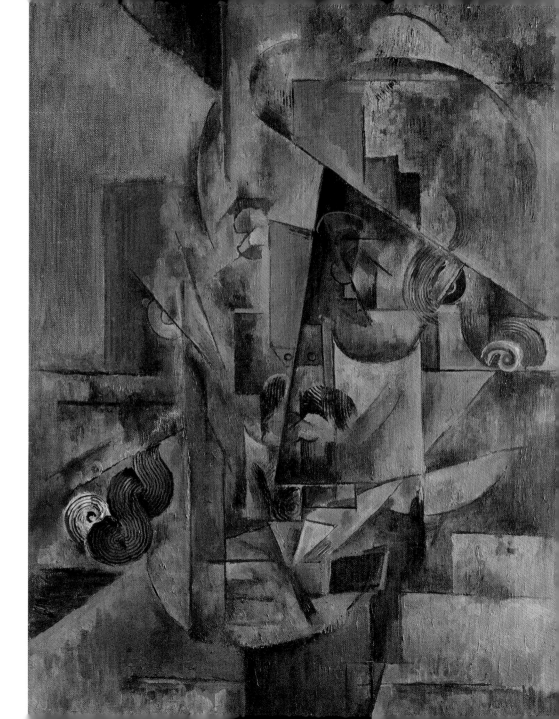

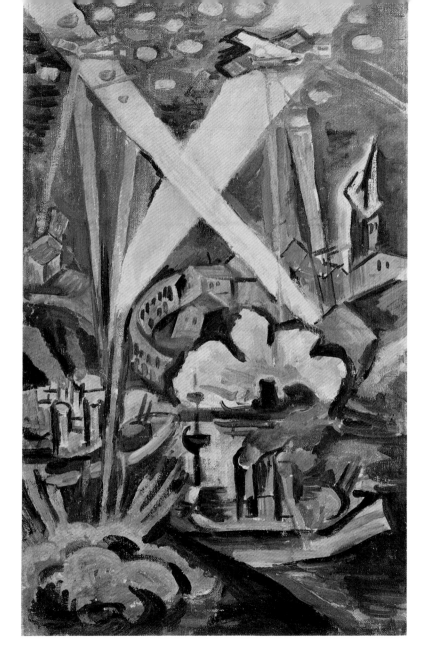

BOHUMIL KUBIŠTA
(Vlčkovice 1884–1918 Prague)

Raid on Pula, 1915

Oil on canvas, 55.5 × 34 cm
Unsigned
Inv. no. O 832
Purchased in 1971

From the point of view of Czech anti-Austrian patriots, Kubišta compromised himself by volunteering for the Austro-Hungarian army; yet another unacceptable event was the sinking of a French submarine in December 1914, an attack that he commanded. However, Kubišta considered his service in the navy only as a necessary solution to his financial situation; he did not connect it with his personal views – all he wanted was to be a painter. During his military service in Pula, he painted two paintings that were inspired by combat or training action. The first is a smaller canvas titled *Coastal Guns in Combat with a Fleet* from 1913. The military exercise is depicted as a futuristically simultaneous scene composed of fragmented shards of visual perceptions. They are dominated by bright cones of searchlights, trails of cannon shots and bursts of shrapnel, among which other visual elements are inserted: the silhouette of a figure, the viewfinder of a telescope, technical instruments, a rudder and ciphers of calculations. As if the disparate scene of the painting corresponds to the atmosphere during the imagined attack, there is also a clear link in the painting to the dynamism advocated by the futurists. Produced two years later, the painting *Raid on Pula* is no longer a dynamic, fragmented scene, but it clearly records a concrete experience of an air attack; the raids did not begin until Italy entered the war in May 1915. Unlike the previous painting, the combination of individual motifs (the city and harbour seen from above, lights and explosions) forms a logical pictorial composition. The construction of the painting is also evident here, based on a well thought-out composition. Two crossed cones of light pointing towards the sky provide the main artistic motif; their diagonal lines, together with the red lines of the paths of bombs dropped from planes, could perhaps also remotely refer to Kubišta's earlier geometric outlines, but this time in quite specific meanings. The temporal element, evident from the juxtaposition of the lines of the dropped bombs and the position of the planes, still plays an important role. The painting has thematic counterparts in similar wartime compositions (Gino Severini, Otto Dix), but these are conceived in an artistically different way. AP

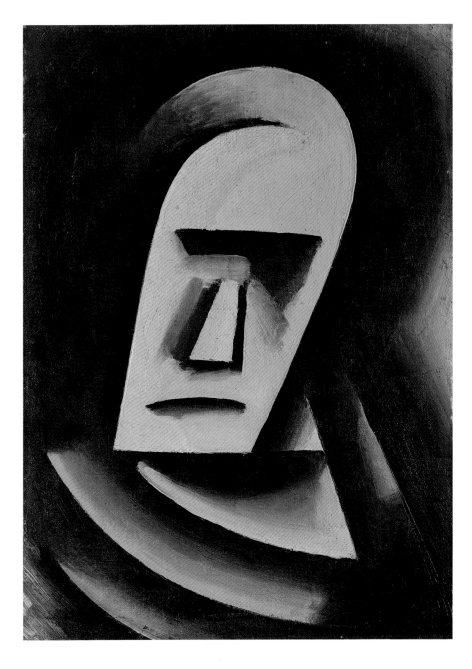

Josef Čapek
(Hronov 1887–1945 Bergen-Belsen Concentration Camp, Germany)

Head, 1915

Oil on canvas, 42 × 30.5 cm

Unsigned

Inv. no. O 893

Purchased in 1973

The painting belongs to a series of paintings that Čapek referred to as
'*têtes d'expression*'. In them, he made use of his studies of African and
Oceanic carvings at the Palais du Trocadéro ethnographic museum in
Paris (1910–11 and 1912). Their simple yet expressive form attracted him
more than the cubist fragmentation of objects in painting, which he
never fully embraced. He intended to elaborate his findings and publish
them in a book, but he succeeded in doing this only much later – he did
not publish his book *The Art of the Primitive Nations* (*Umění přírodních
národů*) with his own sketches until 1938 (only his article 'The Sculpture
of the Black People' ('Sochařství černochů') had been published earlier, in
1918). The expressive heads thus represent an immediate artistic response
to the shape stylisations of ritual masks originating from non-European
cultures. The first of these paintings dates back as early as 1913, with the
largest set dating from 1914–15. Some of them, conceived more or less
as monochrome paintings, refer to the initial inspiration by their title
(*Head with a Headdress, African Head*). In others, Čapek applied more
expressive colour and further strengthened the role of light, as evidenced
by the *Head* from the Gallery of West Bohemia in Pilsen. The shapes are
as if cumulatively carved out of a flat block, the similarity with Kubišta's
Head from the same year, inspired by Sumerian sculpture, is not acciden-
tal – both painters were in contact in 1915 and both inclined towards the
solid form applied in non-European and ancient cultures of that time. In
Čapek's painting, alongside the simplification of form, colour expression
is essential: the painter deliberately chose a reduction of colour, limited
to the contrast of yellow and blue emerging from the dark background.
The vibrant colouring has its origin in the light that seems to spread
from the shapes themselves. At the same time, it bears a symbolic value,
underlining the expression of the depicted emotion. The head then acts
as if it were a magical apparition emerging from the darkness. AP

BOHUMIL KUBIŠTA
(Vlčkovice 1884–1918 Prague)

Head, 1915
Sculpture, patinated plaster of Paris, H. 34, W. 12, D. 15 (head); H. 15 cm, W. 15 cm, D. 20 cm (base)
Unsigned
Inv. no. P 145/b
Purchased in 1967

The task of interpreting the sculpture *Head* by Bohumil Kubišta made art theorist Vojtěch Lahoda reflect on the validity and content of the term 'Czech cubism'. He came to the conclusion that it 'cannot be understood essentially, but plurally, as a set of approaches revolving around the concept of cubism but, in many ways, critical of it'. The Gallery of West Bohemia houses a plaster and tin cast of Kubišta's only sculpture, the most important variant of which, carved in Istrian limestone, is in the National Gallery in Prague. Kubišta did not produce many works during his military service, but in 1915, several major accomplishments were made. The sculpture *Head* is closely related to the paintings *Meditation* and *The Hanged Man*, as well as the woodcut *The Prayer* from the same year. The most closely related to its creation is the eponymous ink drawing, inspired by African art (National Gallery in Prague). In this period, Kubišta tried to express spiritual content through a form alternative to cubism. He looked for it in the 'proto-forms' of archaic, ancient and 'primitive' art. However, the ovoid summative head shape could already be seen in the stylisation of heads in Kubišta's earlier paintings *St. Sebastian* (1912); the heads in the paintings *Obstacle* (1913) and *Fakir* (1914) also contained a hint of it. The origin of this inspiration brings us back to 1910. As the art historian Mahulena Nešlehová pointed out, the drawings of Sumerian statuettes Kubišta produced in the Louvre during Kubišta's stay in Paris testify to his interest in the ideoplastic summative forms of art of the oldest civilisations. He was attracted by the cubic mass of Egyptian sculptures and the ovoid primeval form of the heads of Sumerian art, seeing in them an expression of spiritual intensity. One of his surviving Louvre drawings shows that he also attempted a geometric analysis of the architectural structure of the *Sumerian Head with a Turban* depicting Gudea, the despot of Lagash. It is clear that these impulses had been present in the artist's mind for a long time and that it was only in 1914–15, at the moment of contemplating a 'new form' far removed from cubism, that they assumed definitive form. MR

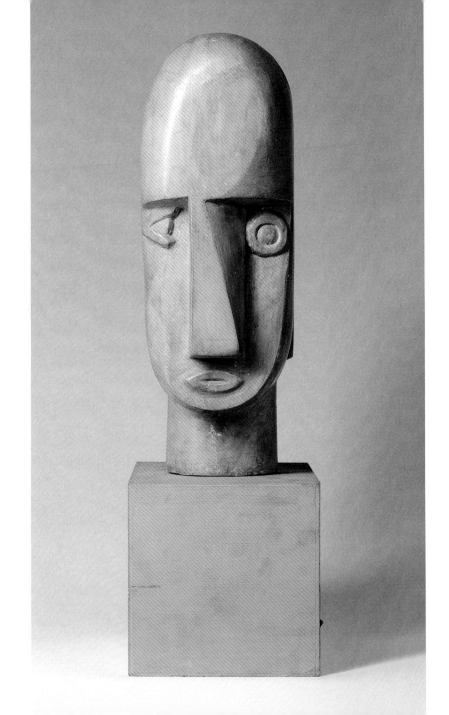

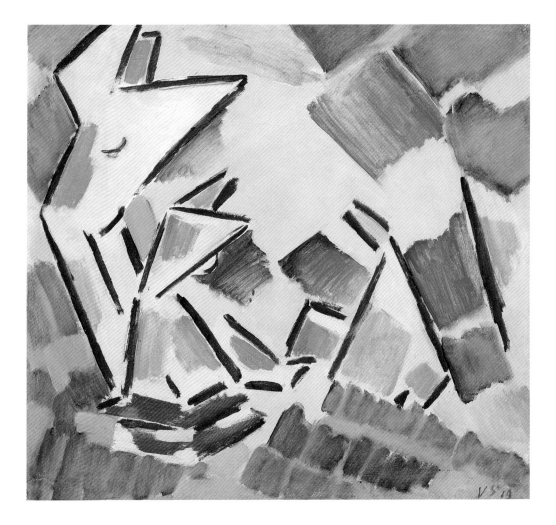

Václav Špála
(Žlunice near Nový Bydžov 1885–1946 Prague)

Three Women by the Water, 1919

Oil on canvas, 75 × 80.5 cm
Signed in the bottom right corner *V Š 19*
Inv. no. O 645
Purchased in 1966

Václav Špála was a painter for whom colour and the painterly gesture were always the basic artistic means. He was therefore unable
to accept the constructed composition and monochromatic colour of
early cubist canvases, yet he aspired to be one of the protagonists of
progressive tendencies in Czech art. He used cubist principles mainly
in the geometrisation of shapes, but he complemented them with fauve
colouring, replacing the rational construction of the painting with an
expressive painterly gesture that was his own. This is evidenced by the
geometrised figures of the painting *Three Women by the Water.* Their
abstracted 'horned' shapes may present the ultimate example of Špála's
cubism, but they also harmonise with the overall concept of the artist's
dynamic manner. The figures, composed of open triangles and rhombi
defined by sharp red paint, stand out from the background indicated by
wide brushstrokes in blue and green tones. The image establishes a specific tension between the linear contours of the bodies and the painterly
hinted natural framework. However, the canvas is not fully covered with
paint: there are empty spots on it, giving the impression of a sketch-like
incompleteness. Špála made several figure drawings dated before 1919,
similarly sketched and geometrical, including an almost identical study
(1915) for this painting. Nevertheless, he did not feel comfortable with the
cubist painting method and abandoned it at quite an early stage in his
career. After 1919, he returned to a more intuitive approach, dominated
by his dynamic style. With a few exceptions, Špála would not return to
cubist geometrisation and fragmentation again. AP

VÁCLAV ŠPÁLA
(Žlunice near Nový Bydžov 1885–1946 Prague)

The Great Bathing, 1919

Oil on canvas, 78 × 105 cm
Signed in the top right corner *V Š 19*
Inv. no. O 806
Purchased in 1970

The motif of bathing runs like a red thread throughout the whole of Špála's painting career, and the gradual transformation of his style can be clearly observed in it. After the initial refraction of shapes from the period around 1912, for which the literary historian Jindřich Toman's term 'refracted style' would perhaps be more of an appropriate one than cubism, and despite the abstraction of female bodies (1915–19), in which he probably came closest to cubism, Špála eventually turned to a style that suited him much better. He broke free from the formal principles of cubism and retained only some partial elements from it. The stylisations and simplifications of shapes remained, but the dynamism of Špála's characteristic style was emphasised. Thus the new form of *The Great Bathing* from 1919 fully suits Špála's painterly nature. Although the angular geometrisation is still visible here (especially in the figures in the bottom right corner), the painting is already dominated by the figure of a woman conceived, despite the simplification, in a more plastic body form. In contrast with the *Three Women by the Water*, no green colour is used here and the whole painting is built up on the contrast of red and blue tones and their alternating intensity. With this two-colour palette, the painter was able to express the physicality of the figures and the terrain of the land, the depth of the water and the clarity of the sky. The whole composition refers to the countryside, nature and elemental forces, subjects far from the urban still lifes favoured by most of the cubists. Nature would also become the artist's main theme in the years to come, as evidenced by a series of landscape paintings in which Špála retained his dynamic style and concentrated mainly on the sensual qualities of colour, especially the blue and green hues. AP

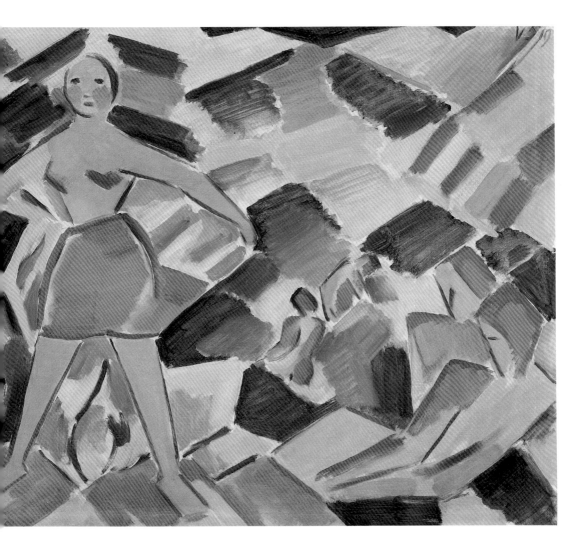

JOSEF ČAPEK
(Hronov 1887–1945 Bergen-Belsen Concentration Camp, Germany)

Prostitute, 1920

Oil on canvas, 42.5 × 36 cm
Unsigned
Inv. no. O 918
Purchased in 1974

Efforts in Czech art to continue the interrupted development of artistic creation and to continue along the paths of pre-war modernism had been made already before the end of the First World War. The poet, literary critic and journalist Stanislav Kostka Neumann, under whose leadership the literary and art magazine *Červen* (*June*) began to be published in March 1918, and the painter Josef Čapek were particularly active in this respect. The latter was the founder of the Tvrdošíjní (The Stubborn Ones) art group, whose first exhibition was also held in the spring of 1918 (apart from Čapek, Václav Špála, Jan Zrzavý and Vlastislav Hofman contributed most of the works exhibited). In terms of style, Tvrdošíjní were a disparate group that had no specific programme; the painters were united only in their quest for modern artistic expression. The critic Václav Nebeský characterised their work as 'diverse modernity' and in a review of their second exhibition, held in 1920, spoke of a 'synthesis of expressionist composition with cubist construction'. This is evident in the post-war work of Josef Čapek, who was also attracted to the paintings of Henri Rousseau. Čapek paid homage to him in his book *Nejskromnější umění* (*The Most Modest Art*), dedicated to self-taught artists, 'Sunday painters' and marginal artistic expressions. This synthesis gave birth to Čapek's 'conscious primitivism', which also very often processes the mundane themes of the urban periphery (prostitutes, beggars, thieves, poor women, drunkards, etc.) and is in harmony with the 'civilism' (an artistic approach reflecting, in a factual and sober way, everyday human life with emphasis on social issues) of the time. He first used the motif of a prostitute in an expressive drawing from 1916; in 1918–19, there are several linocuts in cubist-like forms and in a similar blue-black colour scheme as the painting from the Gallery of West Bohemia in Pilsen. The latter, however, is characterised by different features: formal simplification, compact form and modelling with the use of light and colour. From the previous expression, the staring eyes remained; from cubism, perhaps only the triangle of the face and the oval of the large hat. This was not an isolated return to earlier forms; partial cubist elements would continue to be revisited in Čapek's work. AP

EMIL FILLA
(Chropyně 1882–1953 Prague)

Still Life with a Vase and a Candlestick, 1922

Oil on canvas, 65 × 80 cm

Signed in the bottom right corner *Emil Filla 1922*

Inv. no. O 597

Purchased in 1965

After years spent in the Netherlands during the First World War, Emil Filla returned to his homeland. Even during his involuntary stay abroad, he was active as an artist, but to a lesser extent than during the peaceful times. It was not until his return to Prague (in around 1922), that he began to paint more consistently again. In the first half of the 1920s, he devoted himself almost exclusively to still-life painting. In contrast to his pre-war work, Filla abandoned the geometric order of analytical cubism and moved away from the dark and shadowy painting referring to Dutch baroque paintings that had impressed him during his wartime stay in the Netherlands. He began to use simplified, stylised or abstracted shapes, often further emphasised by contour lines, increasing the colour and loosening the manner, thus strengthening the painterly character of the picture. The art historian Vincenc Kramář described this emphasis on the painterly and sensuous qualities of the work while maintaining its links to the subject matter as 'pure artistry'. He also noted that after returning from the Netherlands, the role of organic objects that do not have a fixed shape – fruits, vegetables, fish, baskets, flowers, i.e. those that represent 'pure matter' – increased in Filla's work. These can no longer be incorporated into a rational cubist composition and, together with the vivid colours and plastic structure of the painting, they emphasise its sensual qualities. In the *Still Life with a Vase and Candlestick*, this 'pure matter' is a cut-in *vánočka* (Czech Christmas cake); it somehow does not fit with the previous universal objects in Filla's still lifes, such as glasses, bottles and pipes, which followed Picasso's patterns. The *vánočka* is a typical domestic component of the festive menu and its characteristic shape defies geometrisation. The clear form and easy identification of this sweet pastry also symbolises the home that Filla had missed for so long. AP

ANTONÍN PROCHÁZKA
(Vážany 1882–1945 Brno)

Bouquet, 1922

Tempera, encaustics, oil and sand on canvas, 70 × 55.5 cm

Signed in the bottom right corner *Ant. Procházka 22*

Inv. no. O 339

Purchased in 1960

The collection of the Gallery of West Bohemia does not house an extensive set of works by Antonín Procházka. He was born in Moravia and spent most of his professional life in Moravian towns and cities, so it is logical that his work is better represented by local galleries. Procházka was a founding member of both the Osma group and the Group of Fine Artists and was linked by a lifelong friendship with Emil Filla. After he married the painter Linka Scheithauer, also a member of the Osma group, in 1907, they stayed in Prague but suffered a life lived in hunger and poverty. In 1910, Procházka accepted a teaching position in Moravská Ostrava to earn his living. He was kept informed of the turbulent events in the Prague art scene by his friend Filla. Procházka's cubism inevitably developed in isolation and acquired an individual colouring, which often deviated from Filla's strict Picassist line. His work is characterised by colourful sensualism, which is also evident in his post-war work, as the painting *Bouquet* demonstrates. This picture was painted in 1922, a year after Procházka had moved to Nové Město na Moravě. It belongs to the period of optimistic cubism of sensually rich flowers, still lifes and figures, in which he discovered painting with wax paints – encaustic, combined with oils and sand. The resulting paintings were sensually appealing colour reliefs in which individual cubist imagery was combined with folk art. The folkloric motif of the pitcher is thus analysed in Procházka's *Bouquet* with a cubist multi-perspective against a background of spatially layered planes, loosely alluding to cubist synthesis. The use of various materials then differentiates the texture of the individual parts of the painting, serving to please not only the viewer's eyes, but also to encourage the tactile sensation. The pitcher, executed in encaustic, evokes the smoothness of the ceramic surface, the flowers in thick oil paste stand out from the surface of the painting and the sand-textured background crowns the haptic impression of the whole composition. MR

Václav Špála
(Žlunice near Nový Bydžov 1885–1946 Prague)

Landscape, 1923

Oil on canvas, 62 × 79 cm
Signed in the bottom right corner *V Š 23*
Inv. no. O 906
Purchased in 1973

After the First World War, Václav Špála became a member of the Tvrdošíjní group, which wanted to imminently pick up the threads of the pre-war years. However, they were given very strong competition from the new generation, which included followers of international avant-gardes. 'Classical' modern art thus lost many of its characteristics of innovative work, but it was still 'modern' in the context of domestic art. It is well-known that cubism was not a style that Václav Špála would naturally adopt. After his initial attempts at cubist geometrisation, he returned to his sensuous, dynamic painting. It might seem that the mosaic-like layering of different colour strokes that was typical of Špála's work corresponds to cubist fragmentation, but its origins appear to be older, going back to Cézanne and his concept of creating spatial illusion on the surface of the canvas through colour relationships and reflexes, and the painting *Landscape* (1923) is solid proof of this hypothesis. Although we see refracted shapes at the trunks and crowns of trees, these are more based on the painter's manner, on dynamically laid out and randomly directed planes and areas. The cubist lessons can still be sensed in the subtext, but there is nothing like the rational layout of the painting. With Cézanne, it has been argued that his technique is so legible that the whole process of painting could be reconstructed, and a similar 'nakedness' of technique is evident in Špála's paintings. From the left, the view of the landscape is framed by a tree trunk; if it was not, we would be faced with an almost abstract painting, a surface covered with gestural brushstrokes in which alternating or graduating blue and green tones are successively laid down on the canvas. However, abstraction is not the point: what we have before us is a vivid depiction of nature, which is one of the basic thematic sources of Špála's paintings. AP

EMIL FILLA
(Chropyně 1882–1953 Prague)

Still Life with a Herring, 1925

Oil on canvas, 31.5 × 88.5 cm

Signed in the bottom right corner *Emil Filla 25*

Inv. no. O 625

Purchased in 1965

In his *Still Life with a Herring*, Filla develops the principle of 'pure artistry', which first appeared in his work at the beginning of the 1920s. It is based on the suppression of the previous cubist fragmentation and on the emphasis the artist places on the sensual qualities of objects that cannot be depicted by means of geometric decomposition. The dominant motif of this painting is a bunch of bananas, which is placed centrally in the painting and attracts attention with its shape and distinctive colour. It is not deformed in any way and most of the objects in the painting are legible, although the painter uses shape exaggerations and spatial layering. According to the title, the main motif should be a herring, but it is only placed at the right edge of the unusually longitudinal format of the painting and is not accentuated by colour. The herring, or fish in general, belonged to the set of Filla's favourite motifs at that time; it represented something torn out of its natural environment and placed in a different ambience, in this case the house interior. An interesting comparison with this painting is offered by Filla's *Still Life with a Herring and Jam* (1922). It is not just the similar tantalising combination of salty and sweet flavours, here even more pronounced, nor the combination of fish imported from abroad and home-made preserve, but the particular format of the painting. In the *Still Life with a Herring and Jam*, it is distinctly vertical (90 × 34 cm) and evokes a composite figure more reminiscent of Giuseppe Arcimboldo's compositional system than a classical still life. In the *Still Life with a Herring*, on the other hand, the format is horizontal and Filla thus assembles objects in a panoramic view, giving the impression of a kind of veduta, with objects playing their own role on the 'stage of things'. AP

EMIL FILLA
(Chropyně 1882–1953 Prague)

Still Life with a Basket of Eggs, 1925

Tempera on cardboard, 52 × 65 cm
Signed in the bottom centre *Emil Filla 25*
Inv. no. O 1009
Purchased in 1978

In the first half of the 1920s, Emil Filla enriched the iconography of his still lifes with common household items such as vases, pitchers, knives and common foods (for example eggs, fruit, herrings, radishes and cheese). He explored the effect of the materiality of these objects, perhaps with reference to the materiality of still lifes by the Dutch old masters, which he had studied extensively in previous years. According to the theorist and collector of cubist works Vincenc Kramář, in 1922 and in the following years 'nothing [...] seems to interest Filla so much as to fill images with sensual reality to the edge of possibility' (1936). Filla's *Still Life with a Basket of Eggs* from 1925 is one of the works of which Kramář wrote that 'their sensual content is still increasing'. At the same time, however, he emphasised that the 'reality' of these paintings was 'always elevated to the spiritual realm'. A special tension is evident in the painting, resulting from the contrast between the principles of painting and drawing. Quivering brushstrokes, sweeping gestures, shadow hatching and smooth blending of planes appear against a background made up of spatial plans representing a wall and a tabletop seen from many angles. The shorter brushstrokes, which at times define the structure of the surfaces, are perhaps meant to imitate wood (*faux bois*) in the spirit of the characteristic collage elements of synthetic cubism. The painterly rendering also determines the pictorial character of some of the objects deformed by simplified multiple perspectives. The silhouettes of the eggs and especially the vase, dominating the centre of the composition, are shaped by the drawing line. Here Filla rehabilitates drawing as an autonomous artistic means equivalent to oils. In 1925, Filla published an article titled *Caravaggiovo poslání* (*Caravaggio's Mission*), in which he attributed to Caravaggio the abolition of the background in favour of 'a dark abstract surface [...] to which the sculpture is in constant proportion as a certain number to zero'. In his *Still Life with a Basket of Eggs*, Filla seems to place 'that Caravaggian "nothing"' on a neutral grey background, corresponding to the interpretation of the dark background of the great Italian's paintings. MR

EMIL FILLA
(Chropyně 1882–1953 Prague)

Still Life / Woman with Fruits, 1925

Oil on canvas, 124 × 64 cm

Signed in the bottom right corner *Emil Filla 25*

Inv. no. O 901

Purchased in 1973

In this painting, Emil Filla returns to the figures composed of flat geometric shapes, alluding to those painted by Picasso in 1918–19 (the figures of Harlequins, *Girl with a Hoop*). They may also remotely resemble the construction of figures in Otto Gutfreund's drawings from 1913–14, which, however, in addition to layering, count much more on the spatial arrangement of individual alternating horizontal and vertical planes. Unlike Picasso, who also laid coloured layers over each other and used a regular geometric or pointillist grid in some of them, Filla's version is far more elaborate in terms of painting. It is as if he wanted to exhaust the maximum possibilities of how each surface can be rendered with paint and brush. It is possible that the painterly character of this work is based on Filla's earlier still lifes, which emphasised the sensuous qualities of colour and 'pure artistry'. Indeed, still life is the second, or perhaps even the main, subject of the painting. The fruit on the tray is conceived as irregular organic shapes that deliberately contrast with the geometry of the composed planes of the figure. However, the painter's manner unifies everything; from this perspective, the perception of the figure, which becomes part of the still life, changes. Filla's painting is thus a thematic synthesis in which both figure and objects merge, but it is also a combination of previous geometry with new organic shapes and painterly structures. This elemental aspect of Filla's work would prevail in the following years and would be reinforced by a more pronounced expression. AP

SVATOPLUK MÁCHAL
(Třebíč 1895–1947 Prague)

Composition – Woman, probably 1925

Watercolour and tempera on paper, 25 × 36.6 cm
Unsigned
Inv. no. K 1179
Purchased in 1994

Svatopluk Máchal was a one-off who, except for an exhibition in 1933, did not participate much in public art life, devoting himself to his profession as a teacher and painting only in his spare time. He was not an autodidact, however; in 1922–26 he studied at the Academy of Fine Arts in Prague and immediately after his studies he received a short-term scholarship in Paris. However, we have no information about what he saw there and what might have influenced him, and even his subsequent work was unknown for a long time. As a painter, he gradually sank into oblivion, which is why the exhibitions he had in 1984 in Pardubice and in 1993 in Prague came as a great surprise (from Pardubice, the Gallery of West Bohemia in Pilsen purchased eight of Máchal's watercolours and pastels, which show the painter's range of styles). He ranged from 'civilism' (an artistic approach reflecting, in a factual and sober way, everyday human life with emphasis on social issues) influenced by the German *Neue Sachlichkeit* ('new objectivity') to compositions in which the lessons of cubism, purism and abstraction concurred. Civilism with social themes is the most typical source of topics for Máchal's works. The painter tried out the angular square style of cubism only marginally; as for the modern trends of the 1920s, he was probably more interested in the aesthetics of purism, which also uses geometric shapes, but rejects the cubist 'decorative fragmentation' and concentrates only on basic forms free from details. Máchal's *Composition – Woman* has a similar character. The first thing that catches the eye is the composition of geometric planes of subtle colours; only later do we notice the fragment of a wheel and bare feet. Other geometric shapes also gradually begin to take on concrete meanings and the initial impression, which invited seeing this work as an abstract composition, is transformed. Although we know of several purely abstract works by Máchal, this painting is not one of them. Even though it depicts the scene in simplified, stripped-down forms, the work does not lose its relation to reality. AP

SVATOPLUK MÁCHAL
(Třebíč 1895–1947 Praha)

Composition – Roofs, probably 1925

Coloured chalks and tempera on paper, 22 × 30 cm
Unsigned
Inv. no. K 1176
Purchased in 1994

The painting *Composition – Roofs* by Svatopluk Máchal features a similar morphology and muted colours as the previous painting; it can thus be dated in the same period of the painter's activity, around the mid-1920s. The flat geometric shapes are perhaps even more closely related to reality, as they depict the basic silhouettes of buildings; these are complemented by other specific motifs – the roofs and chimneys located in the central part of the painting. Here, once again we are not presented with an abstract composition, but with a view of the buildings apparently seen – judging by the borders on the left and at the bottom – from a window. Works formally close to this concept were produced around the mid-1920s – not only by painters developing cubist principles and not abandoning representational elements despite their geometric stylisation, but also in the circle of the avant-garde group Devětsil (Butterbur). Its members combined the stylised forms of synthetic cubism with abstract geometric plane formations, interspersing concrete material details that still maintained a relationship with the visible world. The protagonists of both of these movements, cubism and poetism, advocated by the Devětsil members, jointly rejected pure geometric abstraction, albeit for different reasons. Even the artistic 'rivals' of the 1920s, Josef Čapek and Karel Teige, were close to each other in this approach; specifically, the latter allowed abstraction only as the compositional basis of a painting, to be supplemented by pictorial elements evoking poetic associations. Although Máchal's *Roofs* are close to a series of compositions by the Devětsil members with architectural themes – found, for example, in the works of Josef Šíma, Karel Teige, Jindřich Štyrský or Otakar Mrkvička – their origins are different. Máchal combines a geometric stylisation close to cubism with purist harmonious colouring; he places great emphasis on the manner, which reveals a preoccupation with painterly execution. It is therefore a combination of several impulses, not a distinct stylistic stance. AP

EMIL FILLA
(Chropyně 1882–1953 Prague)

Still Life, 1926

Oil on canvas, 46 × 62 cm

Signed in the bottom left corner *Emil Filla 26*

Inv. no. O 677

Purchased in 1967

In the early 1920s, Filla's work was perceived, especially by members of the younger generation, as heavily dependent on Picasso. In response to Filla's participation in the 1921 exhibition *Tvrdošíjní a hosté* (*The Stubborn Ones and Guests*), the leader of the Czech avant-garde, Karel Teige, wrote that Filla's 'orthodox Picassism remains a developmental error and delusion'. Around 1925, however, there was a fundamental change in Filla's cubist work, which Vojtěch Lahoda attributed to the fact that references to Picasso began to be overwhelmed by an emphasis on Filla's colourist virtuosity. From the very beginning of Filla's artistic career it was obvious that his talent was characterised by a natural feeling for colour and its spontaneous pictorial treatment. In 1926, the Mánes Association of Fine Artists held its 100th exhibition in Prague, where Filla's works found themselves displayed alongside Picasso's paintings. The contemporary commentators pointed out the different colouristic content of Filla's and Picasso's respective works and praised the high quality of Filla's paintings. As a result, Teige fundamentally changed his opinion and stated in his review of the exhibition that the set of Filla's paintings represented the best works of Czech cubism. The *Still Life* from 1926 housed in the Gallery of West Bohemia proves that in the period in question, Filla reached a colourful emotionality, combined with a brisk, light and graceful drawing, which he used to 'inscribe' fragments and whole objects into the picture – in this case a lemon and grapes in a bowl, a 'Baroque' glass, a knife and napkins spread out on a multifaceted deformed table. At the same time, Filla applies an elemental and instinctive approach to colour, shape and material. He changes the painterly manner: instead of regularity and geometry, it is dynamism and fluidity of lines that dominate the whole. Vincenc Kramář has claimed that from 1925 onwards, the sensual component of Filla's painting became stronger. The painter moved towards a constructively organic imagery of dense colour pastes and a painterly gesture of escalated intensity. MR

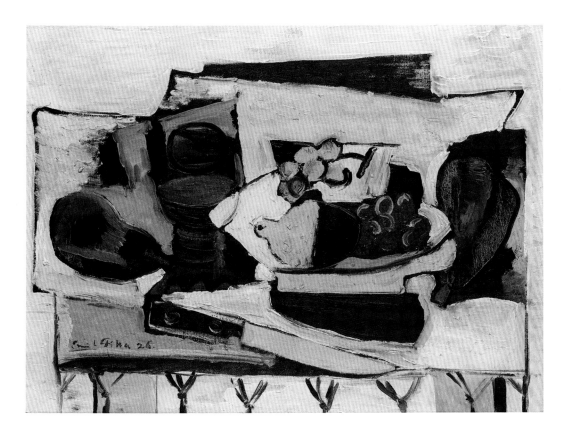

EMIL FILLA
(Chropyně 1882–1953 Prague)

Still Life with a Crayfish, 1927

Oil on canvas, 26 × 33 cm

Signed in the bottom right corner *Emil Filla 27*

Inv. no. O 1026

Purchased in 1979

The 'baroque' glass, which had already appeared in Filla's *Still Life* from 1926 (see p. 90), is also featured in the painting *Still Life with a Crayfish*, painted a year later. It is an object that appears frequently in Filla's still lifes from the 1920s onwards. In 1916, Filla wrote an essay dedicated to the seventeenth-century artists entitled 'Holandské zátiší' ('The Dutch Still Life'), in which he used the example of the glass – an object frequently depicted in Dutch baroque paintings – to characterise materiality not only as a material but also as a spiritual quality. 'The Dutch [were] aware that it was enough to give, for example, the proper value and significance to a glass, for such a picture to have the same expressive and piercing monumentality as, say, a properly emotionally expressed scene of *The Deposition from the Cross*.' In Filla's case, reflecting on the work of the old masters always had consequences for his own work. In the *Still Life with a Crayfish*, the baroque glasses, alongside another favourite motif of Dutch painters, the boiled crayfish or lobster, could testify to Filla's interest in art history; at the same time, though, it is clear that he was trying to follow the Dutch still lifes in their succinct concept of the everydayness, exploring what they revealed about the world as a whole. In Dutch baroque art, the microcosm of the still life represents the macrocosm of the world. Filla's concept of still life can be described in a similar way; even in the smaller ones, such as the *Still Life with a Crayfish*, we encounter this overlap. According to Vojtěch Lahoda, 'the crayfish looks most innocent in Filla's still lifes, as a sensual accentuation of the gustatory richness of what is presented on the table', but around the same time as Filla, 'Salvador Dalí was working with the same motif in the position of a covert sexual symbol'. While the *Still Life with a Crayfish* does not yet sublimate the hidden erotic tension through the crayfish in a surrealistic way, it certainly allows us to trace shifts in Filla's work from the principles of cubist painting to the abstraction of pictorial space and the objects embedded within it. MR

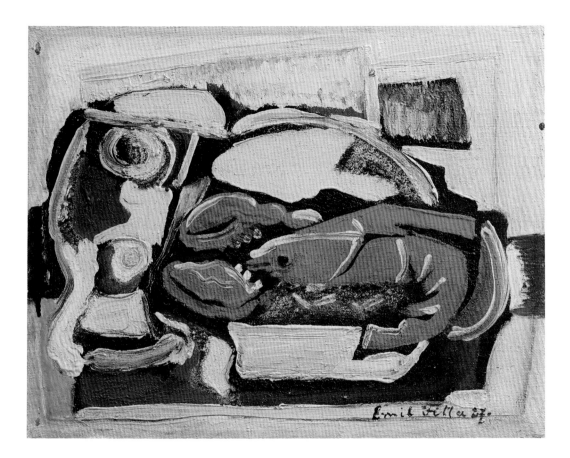

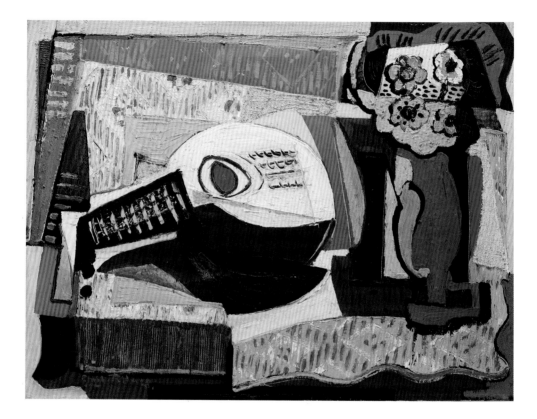

EMIL FILLA
(Chropyně 1882–1953 Prague)

Still Life with a Mandolin, 1928

Oil on canvas, 48 × 62 cm
Signed in the bottom left corner *Emil Filla 28*
Inv. no. O 1145
Purchased in 1980

In the second half of the 1920s, organic constructiveness and a more immediate, sensual concept of colour freed some of Filla's still lifes from dependence on Picasso's model. At the same time, however, Filla's production in this painting genre was so expansive that we encounter very diverse positions within it, of which the one represented by the *Still Life with a Mandolin* from the Gallery of West Bohemia still testifies to a certain connection of Filla to Picasso. The mandolin was featured in a series of still lifes by Picasso in the first half of the 1920s. The inspiration, however, does not remain only on the motif level. In the *Still Life with a Mandolin*, Filla organises the space in a way that was very typical of Picasso at the time. The key feature is the characteristic arrangement of the background by means of flat planes stacked on top of each other in the spirit of a synthetic cubist collage. In the case of Filla's still-life, several decoratively conceived planar elements are projected in front of each other, referring in a sign-like way to the tablecloth on the top of the wooden table (which is partially visible), the carpet on which the table stands, and perhaps also to the motif of the wallpaper or the way in which the room walls are painted. Similar to Picasso in the period in question, Filla is not concerned with reconstructing the spatial and volumetric qualities of the components of a scene through cubist multiple perspectives. Instead of an analysis, a cubist synthesis takes its place, expressing the qualities of space and the variously situated objects within it through planar symbols. The distinction of the texture of individual planes is important to this process. Picasso used admixtures of sand in some of his still lifes; Filla occasionally experimented with enamels or stencils, but in most still lifes he made do with pasty layers of oil paint, which he disrupted, for example, with a comb or spatula. The sign nature, working with outline abbreviation, then asserts itself in the concept of the still-life objects. The drawing line of the mandolin and the vase is multiplied; this way, Filla creates an emblematic symbol of volume. MR

FRANTIŠEK MUZIKA
(Prague 1900–1974 Prague)

Still Life, 1928

Oil on canvas, 86 × 64 cm
Signed in the top right corner *F. Muzika 1928*
Inv. no. O 615
Purchased in 1965

As evidenced by the work of Emil Filla, even in the 1920s, cubism was not entirely doomed; its aspects of 'pure artistry' often became a starting point for younger painters, whom it helped to understand the malleable laws of modern painting. The painterly development of František Muzika illustrates this well. Around the mid-1920s, he gradually abandoned the primitivist style and moved towards paintings that paid more attention to the formal construction of the image, composition and morphology. The main impetus for this change was probably his study trip to Paris, which he made in 1924. Coincidentally, in the same year, the Mánes Association of Fine Artists in Prague organised an exhibition of Juan Gris, the painter with whose works Muzika's paintings were later compared. In the second half of the 1920s, the painting of František Muzika developed in a direction that the art historian František Šmejkal described as 'lyrical and imaginative cubism', a term that Vojtěch Lahoda later modified to 'organic cubism'. By this, they mean that the image is taken out of the cubist geometrisation and natural shapes are used; the depicted objects are simplified and lose their weight, gradually turning into signs that only evoke reality. The *Still Life* belongs to those of Muzika's paintings that still retain a certain relationship to reality, even though the shape of the bowl, its shadow and the outline of the drapery are just flat organic shapes. Dark, unarticulated areas contrast with the soft colours of the objects. His later still lifes would be just harmonious compositions of these shapes and planes; they would become 'pure paintings'. In the late 1920s and early 1930s, Muzika exhibited these works extensively. He included 13 still lifes in his first exhibition in Prague's Aventinská mansarda (Aventinum Publishing exhibition hall, January–February 1930), and it is likely that the Pilsen *Still Life* was among them. A little later, the art critic Karel Teige appreciated that Muzika's paintings spoke an artistic language without the tyranny of the former cubist templates. In this way, he expressed the fundamental shift that the painting style described as cubism had undergone. After this, Muzika would advocate the new tendency of the 1930s, which would lead from poeticism to surrealism. AP

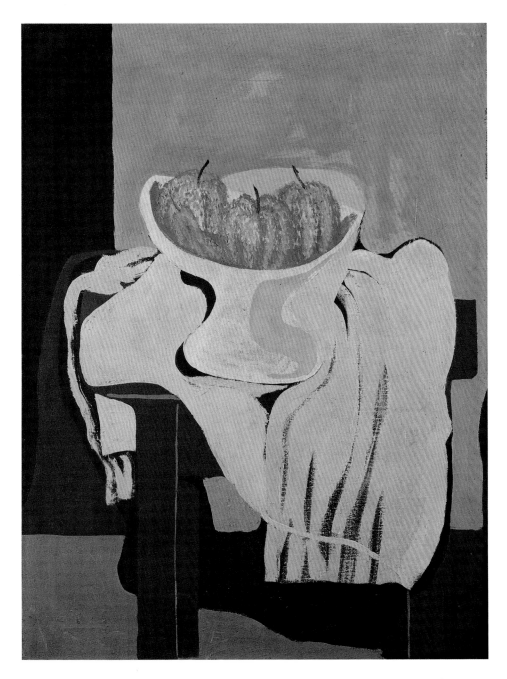

EMIL FILLA
(Chropyně 1882–1953 Prague)

Still Life, 1929

Oil on plywood, 36.5 × 53.5 cm

Signed in the bottom right corner *Emil Filla 29*

Inv. no. O 735

Purchased in 1968

Still Life (1929) by Emil Filla from the collection of the Gallery of West Bohemian belongs to a group of works in which the artist considerably limited and lightened the colour palette and bordered the white, pastel and powder surfaces with a distinctive, contrastingly chosen contour line. Filla also produced ink, gouache and watercolour drawings at the time, in which white and light shades also played a significant role. In this context, art historian Vojtěch Lahoda has spoken of this period as the 'white still lifes' period. Some sections of the painterly rich *Still Life* were probably made with paint applied directly from the tube. This was enabled by using plywood as a medium, as it accommodates such techniques better than canvas. According to Kramář, a kind of 'sweet, heavenly serenity' pervaded these still-life paintings, 'in which the painter uses mostly white colour' and a 'soft grace' manifested itself in them. 'Only an artist of a very lively disposition and high discipline could dare paint such pictures as if made of sugar or snow.' As Lahoda has pointed out, Filla's contemporaries perceived his 'white' paintings as 'visual delicacies, treats for the eyes'. At the same time, the 'white still lifes' display heightened sign elementarism, as evidenced in *Still Life* by the succinct symbols of an apple and a banana in the fruit bowl, a bottle, a pipe and an egg stand. The painting from the collection of the Gallery of West Bohemia is related to Filla's *Still Life with Figs* from a private collection. Both works reach the point of 'pure artistry' in the sense of absolute painterly aestheticisation of the painting plane. Filla exhibited the series of 'white still lifes' at the end of 1929, at the 100th exhibition of the Mánes Association of Fine Artists. At the same time, however, this phenomenon peaked and gradually disappeared, while the sensually and imaginatively shaped female figure began to permeate Filla's work in the late 1920s. MR

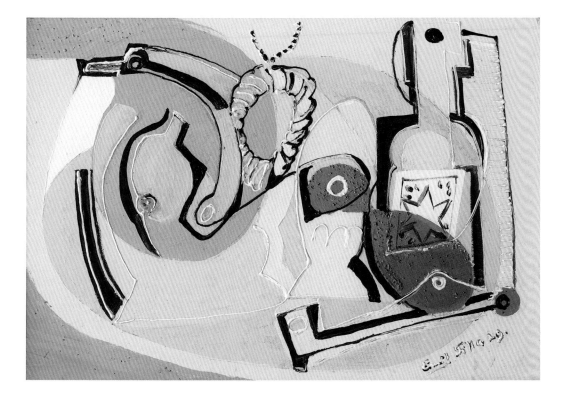

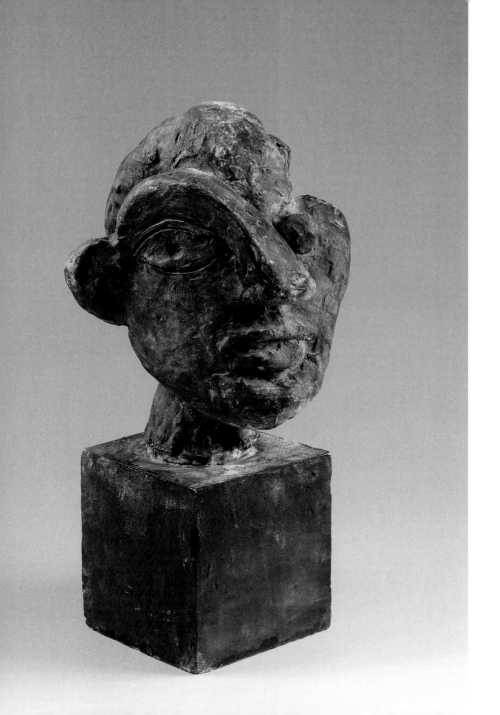

EMIL FILLA
(Chropyně 1882–1953 Prague)

Head of a Man, around 1930

Sculpture, plaster, H. 42.5 cm, W. 22 cm, D. 22 cm

Unsigned

Inv. no. P 193

Purchased in 1987

Emil Filla was first and foremost a painter, but there were periods of his work when he also devoted himself to sculpture. In this medium, he dealt with the same artistic issues that that he simultaneously addressed in painting. The first of these periods date back to 1913–14, when he modelled the cubist *Head*, in which he used the architectural compositional principle of geometric fragments. It was a spatial paraphrase of the sculpturally conceived gouaches of 1912 (*Head; Spectators*). He returned to sculptural work a second time in the early 1930s, resulting in heads and figures marked by primitivising deformation. His last period as a sculptor came in 1937–39, when he created expressive sculptural parallels to his painting and graphic series *Boje a zápasy* (*Fights and Struggles*), responding to the threat of Nazi aggression. Filla created the *Head of a Man* in the early 1930s, when he was transitioning from synthetic cubism to biomorphic morphology. Since he was still associated with cubism even in his transformations, his work is often referred to as 'biomorphic cubism'. The new forms were certainly influenced by his close contacts with the emerging surrealist scene, which saw him as a forerunner; indeed, a similar relationship developed between Picasso and the French surrealists. Thus Filla's work of the first half of the 1930s is a synthesis of cubist stylisation and surrealist fantasy. Furthermore, the inspiring example of primitivism returns again, as it did in the 1910s. This was seen, moreover, in the exhibition organised by Filla in 1935, which focused mainly on his sculptural work (*Head of a Man* being possibly exhibited there, too) and presented it in juxtaposition with African and Oceanic sculptures, as had already happened at the third Prague exhibition of the Group of Fine Artists in 1913. AP

EMIL FILLA
(Chropyně 1882–1953 Prague)

Woman with a Book, 1932

Oil on canvas, 146 × 114 cm
Signed on the right side *Emil Filla 32*
Inv. no. O 875
Purchased in 1973

In 1930, a thematic turn occurred in Filla's work. The previously dominant still lifes began to be outbalanced by themes tied to the stylised female figure. In this context, Vojtěch Lahoda, an expert on Filla's work, speaks of the 'monstrous' paintings of women in which Filla reached the peak of his potential in combining painterly vitality and an animally erotic subtext, albeit not as overtly as seen in the work of Pablo Picasso. Unlike Picasso's surrealist nudes, the sexuality of Filla's women is covert and remote. It was in 1932, when he attended the *Poesie 32* exhibition at the Mánes exhibition hall and began to associate with members of the future surrealist group, that Filla became fully aware of the role of dreaming. Although Filla's support for the surrealists was unequivocal and constant, he remained within the boundaries of conscious creation. Filla's *Woman with a Book* is still in dialogue with Picasso. The motif of the sleeping girl with her head resting on her folded arms recalls Picasso's *Woman with Yellow Hair* or *The Mirror.* Like Picasso, Filla is interested in a closed, lapidary sign which, however, is semantically as communicative as possible. A year later, Filla depicted in the painting *Reader* the face of a sleeping girl from both the front and the profile and increased the significance of the sign. According to Vincenc Kramář, a collector and theoretician of cubism, cubism reverberates in Filla's paintings of women by combining different views of the body or a part of it. In the case of *Woman with a Book,* this tendency can be seen in the treatment of the woman's bosom. Kramář was aware of the affinity of these paintings by Filla with those by Picasso and felt the need to highlight the differences in the respective artists' concepts. According to Kramář, Filla's female forms are more 'irrational', 'earthy' and 'material'. In the paintings of sleeping women, Kramář observes an escalation of a kind of 'naturalness'. Living forms are enveloped by an organic line. Filla's women are much closer to natural organisms, flatter, more sensual and painterly than those of Picasso, which can be defined as sculptures projected onto the surface. MR

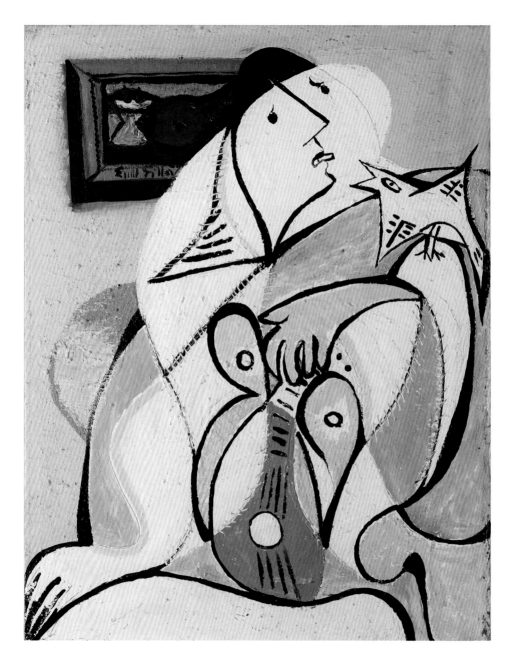

EMIL FILLA
(Chropyně 1882–1953 Prague)

Woman with a Bird, 1934

Oil on canvas, 80.5 × 66.5 cm
Signed in the top left corner *Emil Filla 34*
Inv. no. O 211
Purchased in 1958

A sketch drawing for Filla's *Woman with a Bird* (1934) has been preserved in a private collection, revealing Filla's original inspiration: it shows Eva Jurenová, daughter of Vlastimil Juren, a physician in Louny, with a canary and a guitar. Contemporary photographs also show the girl feeding the canary with a sugar cube she held in her mouth. In the final image, this motif acquires a strong erotic overtone, like the guitar resting in the woman's lap. The sugar cube looks more like a tongue, as if the woman is sensually caressing the canary. The pronounced opening of the guitar may refer to female genitalia, while the neck, which the hand gently touches, has a distinctly phallic characteristic. In the spirit of psychoanalytic interpretations, both the bird and the mandolin may represent hidden erotic contents. The motif of a painting within a painting is remarkable, as behind the woman with the bird, a still life with a guitar and a fruit bowl, clearly signed 'Emil Filla', hangs on the wall. A series of paintings with the motif of a woman and a dog date from the same period as *Woman with a Bird*. Filla and his wife Hana were dog lovers and bred boxers. The vitality and hidden 'exuberance' of the shapes is characteristic of all these paintings. The deformed figures are an expression of the ability of matter to evolve, shape and form, not according to the laws of nature, but imaginative and artistic ones. In the case of *Woman with a Bird*, the motif of hatching in the transitions between the various planar sections of the female body is striking. It is as if the exuberance of the body's mass is stretching the imaginary seams, holding it together to the point of bursting. Surrealist imagery asserts itself in the painting, complementing the cubist imagery of the woman's stylised face, seen in profile and frontal view. In 1933, the surrealist painter Jindřich Štyrský wrote in a review of Filla's exhibition that the realistic observations in the works are woven into the warp of dreams; the artist gives the opportunity to experience 'the illusion of his afternoons', and in his works 'wax faces crumble'. MR

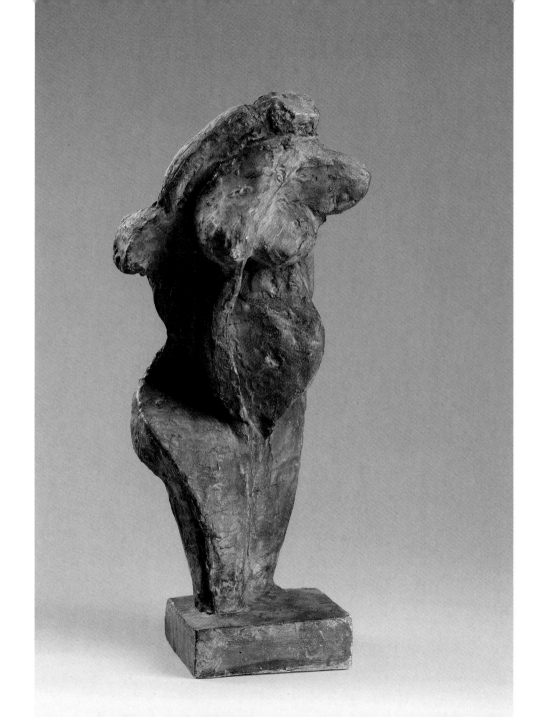

Emil Filla
(Chropyně 1882–1953 Prague)

Female Torso, 1934

Sculpture, plaster of Paris, H. 36.5 cm, W. 15.5 cm, D. 18 cm
Signed on the base *Emil Filla 34*
Inv. no. P 194
Purchased in 1987

Female Torso originated from the second sculptural period of Emil Filla, which falls in the first half of the 1930s. Its connection to contemporary paintings by Filla is obvious, characterised by deformed female bodies, in which a liberated, dynamically conceived morphology dominates in contrast to the previous, perhaps somewhat constraining, geometrisation. Primitivism manifests itself both in paintings and sculptures; the paintings, however, display in addition sometimes almost brutal deformation, a deliberate departure from aestheticism, which becomes a new aesthetic indeed. *Female Torso* is something between an abstract, crude, ancient form with accentuated feminine attributes and a deliberate stylisation of post-cubist forms. In this sculpture, too, a sharp cut is used to create a distinct edge in an otherwise organic mass (leg, torso). Here, the ever-returning residues of cubism can be found in the newly formed works of Emil Filla. The expression of the whole sculpture, however, is already heading elsewhere, and it is therefore not surprising that this and other similar works by Filla would also be labelled as 'destructive cubism', sometimes even 'repulsive'. However, there is also a hint of something that would only become relevant later, namely the first step towards a loss of form – *informel*, which goes back to the unprocessed matter from which the first unartistic ancient forms emerged. A return to primitive meanings is not possible despite all the efforts of many artists; they at least try to evoke the original power of those meanings by using primitivist forms that may still contain the original mystery. AP

Emil Filla
(Chropyně 1882–1953 Prague)

Woman, 1934

Oil on canvas, 128.5 × 79 cm
Signed in the top right corner *Emil Filla 34*
Inv. no. O 1116
Purchased in 1984

The painting *Woman* from the collection of the Gallery of West Bohe-
mia clearly shows the specific way in which Filla treated the impulses
of surrealism. Subconscious elements, automatism or randomly found
objects, so important for the creative process in surrealism, were not
necessary for the creation of Filla's titanic female figures. Rather, they
are hallucinatory sexual objects that Filla created in his imagination
and literally shaped and breathed life into them in a painterly or sculp-
tural manner. According to the contemporary critic Viktor Nikodem,
however, these 'giant nudes' were transformed 'under the influence
of surrealism into ever more terrifying phantoms of darkly demonic
instinctive forces'. Sensuously experienced corporeality, with its erotic
content, takes on 'the fantastic emotionality of prehistoric primitive
idols and imaginings of some titanic chimeras, pre-human monstrous
beings'. Nikodem's emphasis on the plasticity of these women draws our
attention to their connection with Filla's sculptural work, to which the
artist briefly returned, after a 20-year-long hiatus, in 1934. *Woman* was
created at a time when Filla had made several free sculptures – including
Female Torso – and also a relief triptych in which he stylises and deforms
the bodies of monstrous titanic nudes in a very similar way. There are
obvious inspirations from primitivism, understood by Filla as broadly as
in the pre-war period. Prehistoric art, African and medieval sculptures
resonate in the works. Filla proceeded in the medium of painting as well
as in relief. The standing women have a superior, 'ruling' character. Filla
kneads the body in the painting *Women* in a similar way to the one in the
relief triptych. He anatomically deforms and subverts not only breasts
and genitals, but also limbs. The gesture of radical aesthetic subversion
is here an act of freedom. Although Filla's paintings and sculptures of
1934 are marked by surrealism, its designation as 'brutal' or 'expressive'
cubism also seems justified. MR

EMIL FILLA
(Chropyně 1882–1953 Prague)

Susanna, 1935

Oil and tempera on canvas, 130 × 162 cm

Signed in the bottom right corner *Emil Filla 35*

Inv. no. O 827

Purchased in 1971

The painting *Susanna* from the collection of the Gallery of West Bohemia in Pilsen is also referred to in the literature as *Two Old Blokes and a Girl.* According to the art historian Karel Srp, Filla himself named the work this way to avoid the accusation of literariness. It is a loose version of the biblical story of Susanna and the Elders. This theme was also processed in the work of Pablo Picasso, but only much later – in an oil painting from 1955 and a drawing and aquatint from 1966. Picasso projected his own sexual desire into the biblical story; the 1966 drawings in particular seem to be a record of the artist's erotic excitement. Filla, on the contrary, almost never openly expressed his own relationship to eroticism in his work. Although Filla's Susanna may have a sexual subtext (one of the old men 'stabs' the light, soft flesh of the girl's body with his finger – a phallic symbol *par excellence*), Vojtěch Lahoda, an expert on the work of Emil Filla, has proposed two more convincing interpretations. Susanna's rejection of unwanted touches in the painting refers to the part of the narrative according to which the girl resisted the two lechers and preserved her purity, and it is here that the second, more hidden meaning is established: Susanna's 'purity' in Christian tradition symbolised the 'purity' of the Church threatened by Jews and heathens. But Filla had no need to make a statement about religion and the Church at the time and was aiming this parable elsewhere. For him, the triumph of 'virtue' over 'villainy' symbolised the triumph of his 'pure' artistic intentions over the malicious critics who showered him with insults. They constantly compared Filla the 'epigone' to Picasso the 'master', criticising the former's paintings of female nudes of taking on 'monstrous and repulsive forms'. Filla was thus able to use the painting to show his willingness to paint in the spirit of his own convictions, despite his down-to-earth critics. Finally, according to Lahoda, the theme of Susanna and the Elders also offered Filla the opportunity to thematise old age and ageing. MR

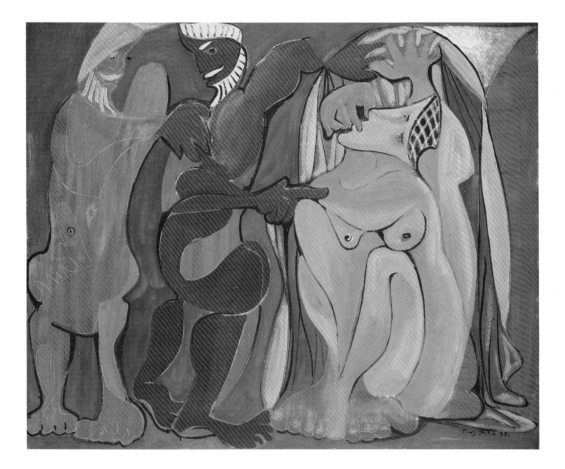

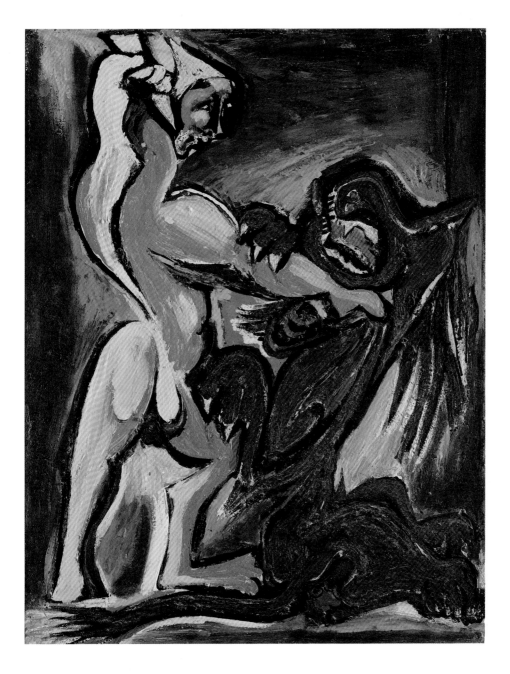

EMIL FILLA
(Chropyně 1882–1953 Prague)

Fight, 1936

Oil on canvas, 66 × 51 cm

Signed in the top right corner *Emil Filla 36*

Inv. no. O 936

Purchased 1975

The motifs of animal fights or the struggle between an animal and a man first appeared in Emil Filla's work in 1936 and remained to be developed over the next three years. These paintings became part of the extensive cycle *Boje a zápasy* (*Fights and Struggles*), exceptional in the message it conveys. The cycle was probably originally created as a loose inspiration from ancient myths in which heroes (most often Heracles) conquer wild animals and monsters. However, in the context of the escalating political situation in Europe before the Second World War, the work assumed a new meaning. Like Pablo Picasso, whose work Filla followed and who created the famous painting *Guernica* in 1937, Filla felt the need to draw attention to the dangers of Nazism. He translated its threat into allegories of ambush, fight, destruction and the struggle between good and evil. Filla's fights and struggles take the form of paintings, drawings, prints, small sculptures and reliefs. Usually it is a pair of struggling figures – a man and an animal or two animals (a horse or a bull attacked by a lion). The background is a blank area, or the landscape is only symbolically indicated. The most striking feature of these works is the pronounced expression. The figures are depicted expressively twisted, intertwined, deformed; the animals often have exaggeratedly emphasised paws and mouths, even with distinct traces of blood. The cubist aesthetics here completely recede into the background: what matters are the symbolic meanings the painting conveys. This is one of the reasons why Emil Filla was arrested for his politically engaged anti-Nazi stance in September 1939 and imprisoned in Buchenwald concentration camp until the end of the war. IS

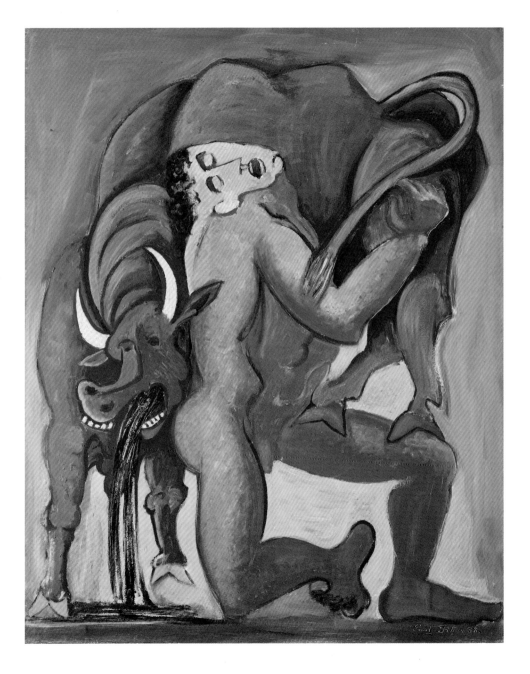

Emil Filla
(Chropyně 1882–1953 Prague)

Theseus Carrying a Bull, 1938

Oil on canvas, 162 × 130 cm

Signed in the bottom right corner *Emil Filla 38*

Inv. no. O 956

Purchased in 1976

In 1936–39, Emil Filla worked on his cycle *Boje a zápasy* (*Fights and Struggles*), which is seen as a reflection of the political and social situation in Europe of that time and a warning against Nazism. The initial inspiration for the cycle, however, seems to have been Greek myths, and it only gained topical content as events unfolded. The scenes of Greek heroes battling mythical creatures stem from Filla's deep interest in ancient mythology. The most frequently depicted hero is Heracles, who, in Filla's understanding, represented the embodiment of freedom and victory over evil. In Filla's series of works with the theme of battles, Heracles faces the Cretan bull, the Nemean lion, the Erymanthian boar, the Stymphalian birds, the three-headed dog Kerberos, the horses of Diomedes and the giant Antaeus. Heracles is also the central figure of the eponymous graphic series *Boje a zápasy* (*Fights and Struggles*) consisting of 24 sheets (1937). Of other mythical figures, the cycle features Theseus fighting the Cretan bull, Perseus with the head of Medusa, Orpheus dying in a tangle of animal and human bodies and Phaethon falling from the sky among the floundering horses. Theseus raising a dead bull is one of Filla's last mythological paintings. The previous tense expression recedes, the struggle has been brought to a victorious end. The gesture and colouring calm down, with the only accent colour being the red blood gushing from the dead bull's mouth and the bright figure of Theseus, who also creates a dominant vertical of expression and meaning in the composition. He is a symbol of the victory of the stronger over the weaker opponent. Emphasis is also placed on the juxtaposition of Theseus' human face and the bull's head, which again must be seen in the political context of the time. Filla presented works on the theme of fighting and struggle at an exhibition of his new works in the spring of 1938. This painting was apparently among them. IS

EMIL FILLA
(Chropyně 1882–1953 Prague)

Fight / Bull Attacked by Lion, 1938

Drawing ink on canvas and plywood, 119 × 79 cm
Signed in the bottom left corner *Emil Filla 38*
Inv. no. O 596
Purchased in 1965

With the approach of the Second World War, animal fights began to pre-dominate and mythological themes were reduced in Filla's work. The main heroes here are a lion, a horse and a bull. Inspiration is offered by Pablo Picasso's series of works on the *corrida,* in which the duel between the horse and the bull plays a major role. However, this theme has another, very important connection. The theme of beasts, fights and struggles can be linked to Filla's long-standing interest in collecting small sculptures of the Renaissance and his specialist interest in Scythian art. Filla's extensive collection included, for example, an Italian bronze statue of the *Pantheress* and a small Florentine marble statuette, *Heracles with the Cretan Bull.* He also devoted himself to the subject from an art historical point of view. In 1938, he published a study entitled 'Problém renesance a drobná plastika' ('The Problem of the Renaissance and Small Sculpture'). Similarly, he also dealt with Scythian art, almost unknown in the Czech context until then, about which he wrote the treatise 'Stepní zvířecí styl' ('Steppe Animal Style') in 1932. The light ink painting that Filla used in this work has another connection. It indicates a great inter-est in Chinese art, which Filla also dealt with theoretically. The subject matter remains the same, but the execution is different. The foundation is a linear drawing in red and black ink on canvas and the picture is more akin to a drawing than a painting. The interest in non-European cultures, which cubism directed towards African and Oceanic carvings, here shifts to a completely different cultural circle. Instead of stylised 'primitivism', there is a perfect drawing in the abbreviated depiction of movement. IS

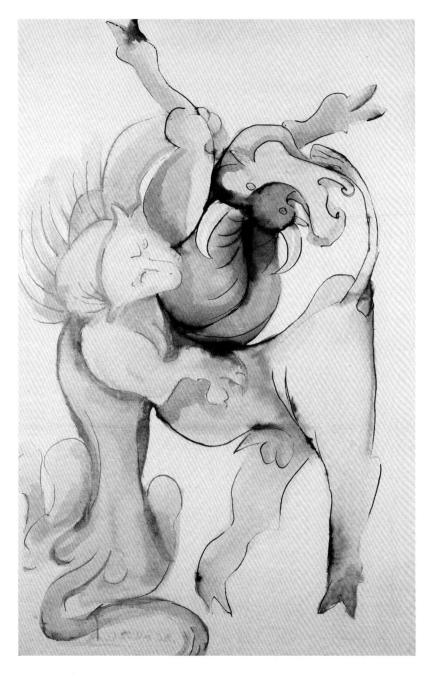

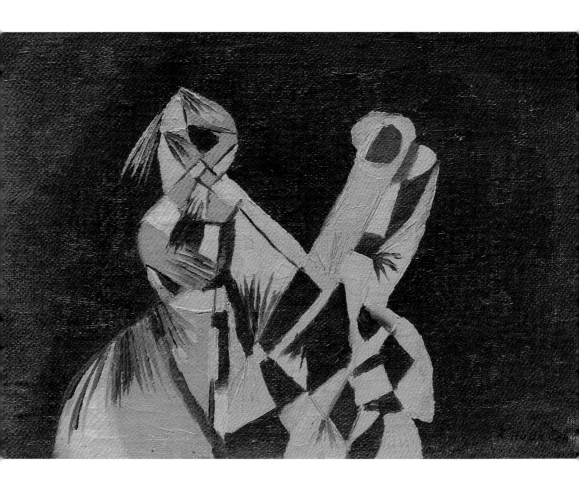

FRANTIŠEK HUDEČEK
(Němčice 1909–1990 Prague)

Columbine and Harlequin (originally Pierrot and Columbine), 1937

Oil on canvas and cardboard, 24 × 34.5 cm

Signed in the bottom right corner *F. Hudeček 37*

Inv. no. O 1038

Purchased in 1980

František Hudeček was born in 1909; cubism was thus already history to him. He began his artistic career in the 1930s and, as a young painter, drew inspiration from the forms of old art, while exploring other possibilities of artistic means and trying to experiment with new techniques. After an initial fascination with the newly emerging surrealism, he turned to more rational practices and a search for order. Cubism and the avant-garde of the 1920s, which focused on abstraction, provided him with support in this search. Similar paths were followed by other generational peers, such as František Gros or the slightly younger Jan Kotík, whom Hudeček later met as a member of Skupina 42 (Group 42). The artists in this group were not cubists, but they were attracted by the inner order of cubist paintings, the deliberate simplification of shapes and geometrisation. Post-cubist stylisation is also evident in this small Hudeček painting. Figures from the traditional *commedia dell'arte* were a frequent subject for painters, with Harlequin appearing most often in the cubists' paintings, not least for the geometric pattern of his costume (Picasso, Juan Gris). In Czech art, Hudeček could build on specific examples, such as Kubišta's painting *Harlequin and Columbine* (1911) or its strongly geometrised variant by Václav Špála (1922). The distinctive outlines and theatrically illuminated figures emerging from the dark background are reminiscent of Josef Čapek's pre-war paintings. The pattern of Harlequin's costume in this painting is the starting point for the chessboard alternation of colours, albeit in a somewhat looser version; the figure of Columbine is similarly conceived. It is possible that the objectively given geometric structure of Harlequin's clothing may conceal a visual parallel with Hudeček's later, probably best known works, such as *Night Walkers* (1940s). In these works, too, the silhouette of the figure is often filled with a geometric grid, a linear labyrinthine structure or other abstracted signs, but this time without a link to the specific subject. AP

This edition © Scala Arts & Heritage Publishers Ltd, 2022
Text and photographs © The Gallery of West Bohemia in Pilsen, 2022

First edition published in 2022 by
Scala Arts & Heritage Publishers Ltd
305 Access House
141–157 Acre Lane
London SW2 5UA, UK
www.scalapublishers.com

In association with the Gallery of West Bohemia in Pilsen
Pražská 13
301 00 Pilsen, Czech Republic
www.zpc-galerie.cz

ISBN: 978-1-78551-341-1

Project managers: Bethany Holmes (Scala) and Tomáš Hausner (GWB)
Editor: Roman Musil
The authors of the respective entries are marked by an abbreviation
at the end of each entry: Roman Musil (RM), Alena Pomajzlová (AP),
Marie Rakušanová (MR), Ivana Skálová (IS).
Translation: Tomáš Hausner and Connaire Haggan
Proofreading: Catherine Bradley

Graphic design: Bušek & Dienstbier
Photography: Karel Kocourek, Oto Palán
Printed in Turkey

10 9 8 7 6 5 4 3 2 1

FRONT COVER:
BOHUMIL KUBIŠTA,
The Resurrection of Lazarus,
1911–12

PP. 2–3:
EMIL FILLA,
Woman with a Book,
1932

BACK COVER:
EMIL FILLA,
Still Life / Woman with Fruits,
1925